IMAGES
of America

PLAINFIELD TOWNSHIP

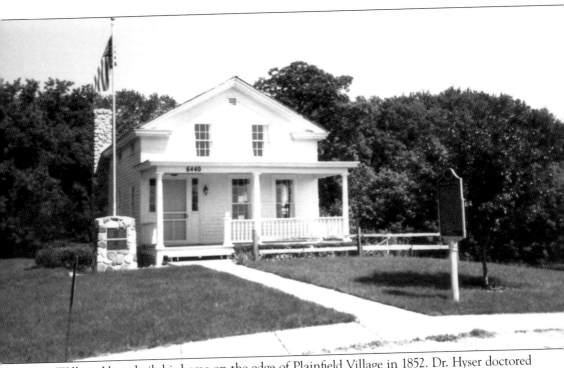

Dr. William Hyser built his home on the edge of Plainfield Village in 1852. Dr. Hyser doctored the residents of Plainfield and surrounding environs, with a break to serve in the Union army during the Civil War, until his death in 1909. His house, the last remaining structure of Plainfield Village, is now the Hyser Rivers Museum, a monument to the resilience and dedication of Plainfield Township residents. The house, now at 6440 West River Drive, was donated to the township by Donald and Florence Hunting and is maintained by the Plainfield Township Historical Society. (Plainfield Township Historical Society.)

On the cover: Martin and George Buth host former president Gerald R. Ford at the family farm in 1950, when Ford was running for reelection to Congress. Ford, Grand Rapids' most famous son, died on December 26, 2006, in Rancho Mirage, California, and is buried in Grand Rapids. Farming and politics were in the Buth family blood. Martin Buth, right, farmed his family's acreage on Buth Drive before entering politics in 1958, when he was elected to the Michigan State House of Representatives. He served until 1982, the year his son George, the child in the picture, ran for a seat on the circuit court, which he still holds. Martin served as a township commissioner after his tenure in the Michigan State House of Representatives. (Buth family.)

IMAGES
of America

PLAINFIELD TOWNSHIP

Ann E. Byle

ARCADIA
PUBLISHING

Published by Arcadia Publishing
Charleston SC, Chicago IL, Portsmouth NH, San Francisco CA

Printed in the United States of America

Library of Congress Catalog Card Number: 2007942492

For all general information contact Arcadia Publishing at:
Telephone 843-853-2070
Fax 843-853-0044
E-mail sales@arcadiapublishing.com
For customer service and orders:
Toll-Free 1-888-313-2665

Visit us on the Internet at www.arcadiapublishing.com

*To those whose hearts and long lives have helped make
Plainfield Township what it is today and who made this book richer
because of their stories: Maxine Pritchard, Walter Schillinger,
Martin Buth, Helen Finger, Chuck Weldon, Leona Kroes Benson,
Letha Mohl, Andy Dykema, and Wendell Briggs.*

CONTENTS

ACKNOWLEDGMENTS

This book was birthed with the help of many people. It was Plainfield Township itself—made manifest in Cathy Beattie and Priscilla Walden—who bought into the project from the beginning and generously opened the township office to me. Leona Kroes Benson, representing the Plainfield Township Historical Society, was most helpful in suggesting contacts, answering questions, and providing invaluable input. A special thanks goes to the Grand Rapids Public Library Local Historical Collections department for its wonderful resources and kindness, most especially Karolee Hazlewood and Chris Byron. So many people shared their stories and their photographs, and for that I am most grateful. The list is long: Marj Wiltse, Ruth Jost Kommer, Virginia Tyler, Louann Larsen, Nancy Buth, Dan and Nancy Burns, Paul Krupp, the Smitter and Modzeleski families, Marian Annis, Larry Lee, Paul Morrissey, Patsy Ghysels, Joel Dykema, Bruce Biemers, Pat Fry, and Sam Pizzo. Those to whom the book is dedicated provided me with hours of interesting discussion, wonderful photographs, and even more wonderful insight into the early years of this vital township. I must also thank my husband, Ray, and my children—Bree, Abby, Jay, and Jared—for letting me sit for hours in my office, lost in years gone by.

INTRODUCTION

Plainfield Township is unique in its variety: cities and farms, business districts and baseball stadiums, mighty rivers and rolling golf courses. Residents live in brand-new subdivisions and 150-year-old farmhouses. Yet new and old come together in a lively combination that makes Plainfield Township what it is today.

Early settlers were a hardy group that cut down forests to create farms; they built mills to make lumber and grind grain; they ran blacksmith shops and gravel pits and hotels and restaurants. They schooled their children, attended church, and faced tragedy with hardiness and dedication.

Township residents certainly faced their share of hardship. The Grand River flooded most every year, some years worse than others. One flood took out the Plainfield Bridge. Another sent water through the streets of Comstock Park. Snowstorms closed roads. Storms ruined crops. And tornadoes wreaked havoc in the area twice in a decade. In both 1956 and 1965, tornadoes racing southwest to northeast took out houses, barns, and stands of trees. These events are part of the collective history of Plainfield Township.

It was the Native Americans who first delighted in the rolling plains and lovely fields that evolved into the name Plainfield. Plainfield Village sprang up along the north side of the Grand River at its northernmost point once the settlers arrived, growing into a thriving community. Its post office was called Austerlitz because a Plainfield post office already existed in the state. It is gone now, though, the victim of railroads and improved river transportation, plus the farm dreams of a rich Grand Rapids businessman named Joseph Brewer.

Plainfield Township at one time included Cannon Township and Algoma Township, until Cannon organized and separated in 1845 and Algoma in 1849. In 1847, the area south of the Grand River separated from Grand Rapids Township and joined Plainfield, creating the final dimensions that remain today.

The township's early days were times of growth. Comstock Park grew thanks to the tanneries and mills that employed many, but it was the influx of money and land from Charles C. Comstock that not only brought about a name change but also brought more business and people.

Folks from all over flocked to the West Michigan State Fairgrounds each year. The art building, animal barns, and racetrack were huge draws until the fairgrounds closed, replaced for a short time after World War II with an airport. The airport closed as well, making way for the ever-popular Speedrome. Drivers from all over came to show off their cars and skills for 15 years until it too closed when the state needed the land for the new U.S. 131 expressway.

Belmont remained a small town, content in its smallness and proximity to bigger cities. These days it is home to the Plainfield Township offices, staying true to its small-town image.

Business has changed in Plainfield Township. What at one time was primarily farmland is now home to a diverse business landscape. Fifth Third Ballpark is home to the West Michigan Whitecaps, while West River Drive boasts a growing number of small businesses. The land south of the Grand River on Northland Drive was at one time only swamps and lowlands. Now that corridor is full of restaurants and stores and the popular Versluis Park. Yet it is the corner of Northland Drive and Cannonsburg Road that has seen the hugest changes. At one time a huge dairy farm home to the Brewer mansion and Christ Church, the property is now a thriving gravel business and a golf course, forever changing the contours of the land.

Today Plainfield Township is growing and changing. Some farms continue to operate, and a good number of folks live on the land their fathers and grandfathers bought and worked. Subdivisions exist on land that once belonged to farmers. Four-lane bridges replace ferry crossings. Modern school buildings replace the one-room schoolhouses. Yet the history of Plainfield Township retains its allure. Folks are eager to share their memories, relive the old days, and rediscover the hardy men and women who helped make Plainfield Township what it is today. Enjoy the history!

One

PLAINFIELD VILLAGE

The northernmost point of the Grand River is a natural gathering place, first for the Hopewell Mound Builders and later for the Mascouten Indians. Later the Ottawa Indians created a village on the bluffs above the river and a burial site below the bluffs. The site was on the Plainfield-Sheridan Indian Trail between the rapids of the Grand River farther south and the Saginaw Bay area to the east.

White settlers used the trail as well, both as a commercial route and a route into the unsettled areas to the north and east. Although early explorers saw this region years earlier, it was not until the Native American treaty of 1836 ceded the land to white settlers that the town began to take shape.

The first white men in the area included George Miller, who settled on the bluffs above the river in 1837, and Andrew DeWitt Stout, who settled along the river and established a ferry service, blacksmith shop, and school. The first deaths recorded in Plainfield Village were George Miller's infant twins, with the first birth that of Cornelia Friant and the first marriage that of Margaret Miller and William Livingston.

Plainfield Village grew and prospered enough to rival Grand Rapids as the largest city in the area, but its fate was decided in 1857, when the new railroad ended dependence on river travel vital to Plainfield Village. Later the railroad bypassed Plainfield, instead going through Belmont to Rockford. The village dwindled to a few inhabitants, although it was not until the mid-1920s that all buildings save one were destroyed to make way for Grand Rapids businessman Joseph Brewer's new farm.

Today the business district south of the Grand River along Northland Drive mirrors the vital town that once graced the other side of the river.

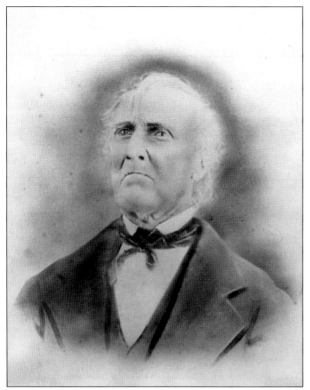

Andrew DeWitt Stout left New York to settle in the Grand Rapids area in 1834, where he set up a blacksmith shop. He moved to Plainfield Township in 1837 in part because he did not like the swamps and mosquitoes in Grand Rapids. His son, Andrew DeWitt Stout II, grew up in Plainfield Township and served in the cavalry during the Civil War. Andrew eventually moved to Courtland Township where he died on January 28, 1885. He also had a daughter, Sarah. Phoebe Stout, much loved by her husband, was one time carried in Andrew's arms out the door to escape their burning home. Phoebe's long dark hair, which reached to the floor, caught fire but was quickly put out. (Plainfield Township Historical Society.)

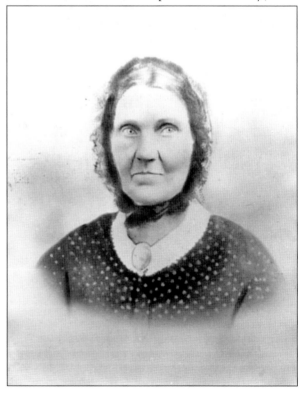

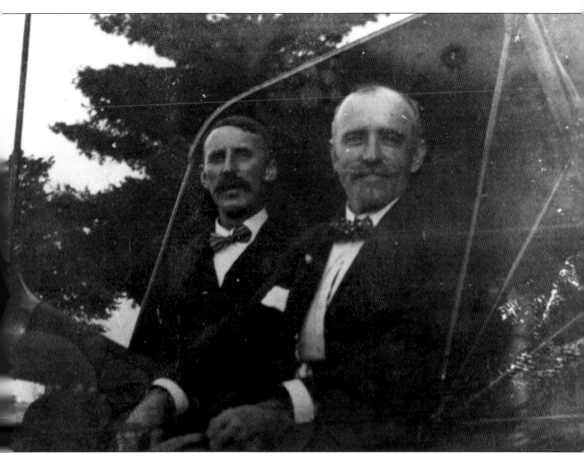

Dr. William Hyser, born in New York in 1824, graduated from medical college in 1846 and from Buffalo University in 1850. He moved to Plainfield that same year, married Jeanette Saunders, and built his two-story home in 1852. Dr. Hyser served the residents of Plainfield Township for 13 years before enlisting in 1863 in the 6th Michigan Cavalry. He served the Union army at the Battle of Gettysburg, was injured and discharged, reenlisted, and was finally mustered out in 1866 with the rank of captain. Dr. Hyser again cared for the residents of Plainfield Township until his death in 1909. He and his wife had four children: Herman, Jennie, Frank, and Albert. Dr. Hyser is shown here, right, in a buggy with Lucius Visser. (Plainfield Township Historical Society.)

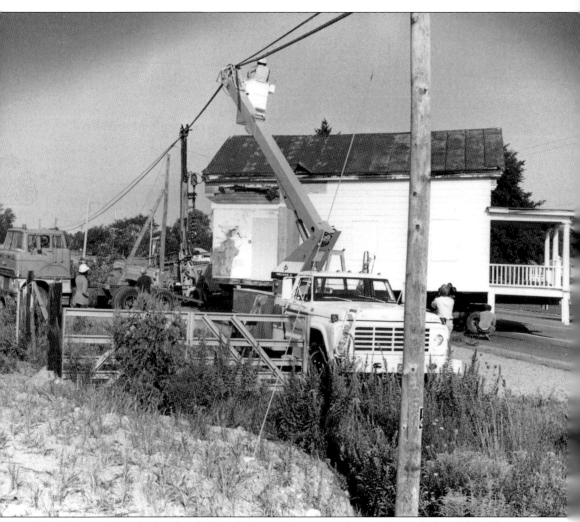

Dr. William Hyser built a lovely Greek Revival home on the outskirts of Plainfield Village in 1852. He treated his patients in the front room, raised his family, and even served as Austerlitz postmaster in the home, which sat on the north side of West River Drive. Plans to widen West River threatened the house, which was moved temporarily down the street to Department of Natural Resources property near Indian Drive on July 3, 1973. The house was finally moved in August 1976 to property donated by Wendell Briggs, where it rests today. It was restored to its former beauty and now is home to the Hyser Rivers Museum. (*Grand Rapids Press*, August, 26, 1976.)

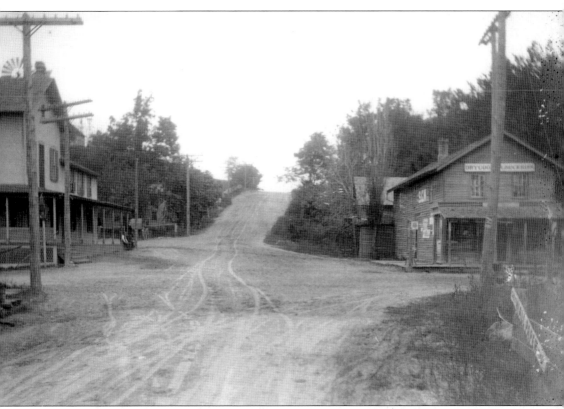

This early picture of Plainfield Village shows a dry goods store on the right and an early hotel on the left. The village was located near the intersection of what is now West River Drive, Cannonsburg Road, and Northland Drive. The buildings in Plainfield Village were all torn down in the early 1920s after Joseph Brewer bought the property. (Grand Rapids Public Library.)

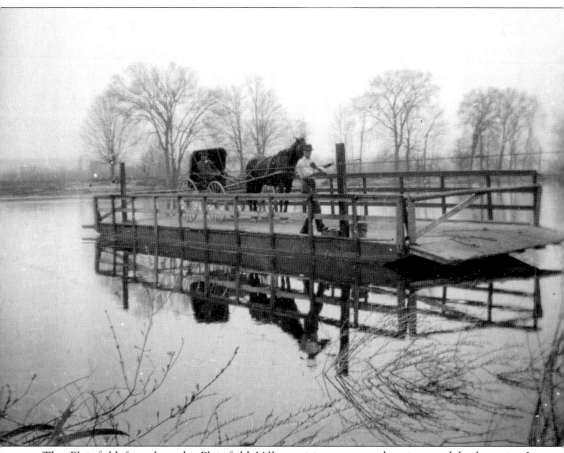

The Plainfield ferry brought Plainfield Village visitors across the river and back again. In operation since about 1837, the ferry service ended with the construction of a wooden bridge in 1850. Note the horse-drawn carriage and the rope used to guide boats across the river. (Grand Rapids Public Library.)

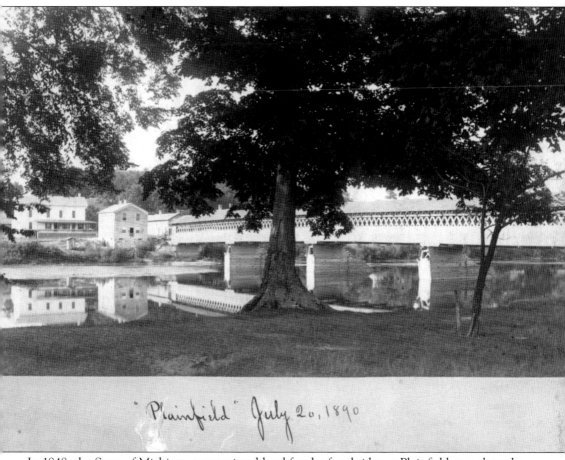

"Plainfield" July 20, 1890

In 1848, the State of Michigan appropriated land for the free bridge at Plainfield to replace the toll-charging ferry. The lattice bridge, a wooden covered structure, was built by David Burnett and featured 3-by-12-inch planks 16 feet long. It stood for over 40 years until March 12, 1892. High floodwaters on the Grand River had taken out the upriver Knapp Avenue bridge, which floated downriver to slam into the Plainfield Bridge, which buckled in the middle. The south half of the bridge swung around to rest against the south bank, but the north half floated a mile and a half downstream to rest against the head of Grand Island. The bridge was dismantled, with part of the salvaged lumber used for pews in Christ Church at Plainfield Village. Note the buildings making up Plainfield Village north of the river in this photograph taken on July 20, 1890. (Grand Rapids Public Library.)

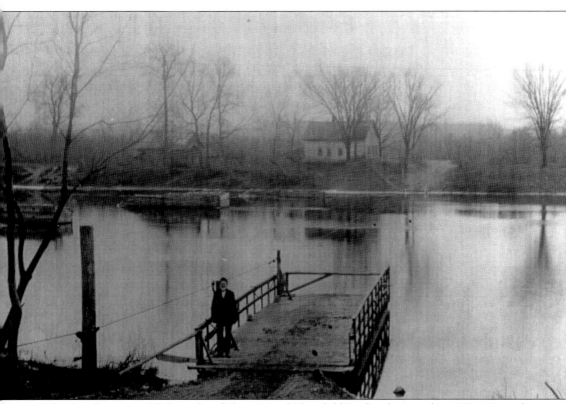

This free ferry most likely replaced the original Plainfield Bridge destroyed in 1892. Note what is left of the bridge supports in the river to the left. The ferry operated until about 1900, when a new iron bridge was constructed. That bridge remained in use until the 1920s, when it was replaced by a concrete structure. That structure was widened in the early 1960s, with additional work done on the bridge in 2005–2006. (Rockford Historical Society.)

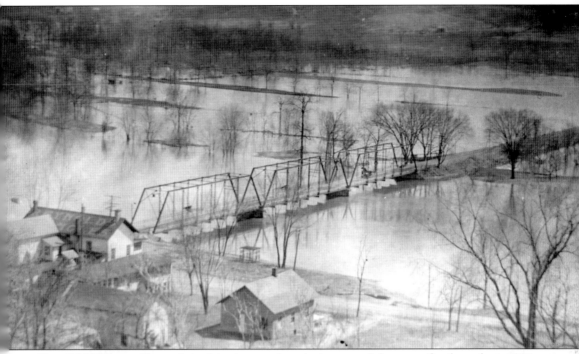

Plainfield Village still stands in this picture taken during one of the many floods, perhaps 1904. Note the iron bridge, which was built in about 1900 and used until the 1920s. The roof of the building in the left of the picture says Reynolds Buggies. The lowlands, swamps, and lagoons south of the river flooded heavily, making it necessary to raise the roadbed, visible here. In later years, the road south of the river was raised to its present level. That land is now the business district between Plainfield Avenue and the river. (Plainfield Township Historical Society.)

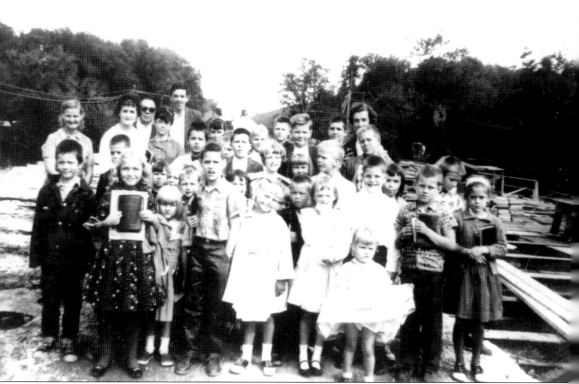

The two-lane Plainfield Bridge was under construction in 1963, but that did not stop this group of children from attending Sunday school. Maxine Pritchard picked up the kids on the north side of the Grand River and then had them walk carefully across the bridge on boards to meet a bus on the other side that took them to Berkeley Hills Wesleyan Church on Ball Avenue in Grand Rapids. Pritchard first used her old Ford car in 1963, then a station wagon, and finally a bus, with numbers eventually reaching 88 children. She did the route for three years before turning it over to another driver. (Maxine Pritchard.)

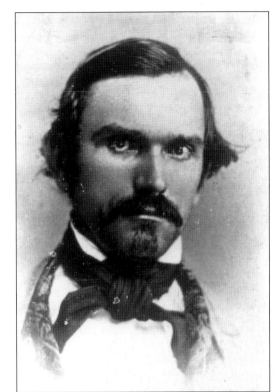

William H. and Sarah Moore McAuley came to Plainfield Village in 1865 from Ontario. They had nine children, but only six survived infancy. William passed his blacksmithing trade onto his sons John, Herbert (Bert), and Harry. Bert became the Plainfield Village smithy and then owner and operator of the Grand River Club, a popular members-only club that featured dances, chicken dinners, and lots of good times. (Plainfield Township Historical Society.)

Bert McAuley, left, shown here with his brother Erasmus and Katie, married Ada Scoville, a native of Plainfield, in 1879. They had one son, Claude, who died in 1935, leaving one daughter. Bert died in 1930 of heart disease at age 75. His wife lived in the family home, south of the Grand River Club site, until her death in 1946. (Rockford Historical Society.)

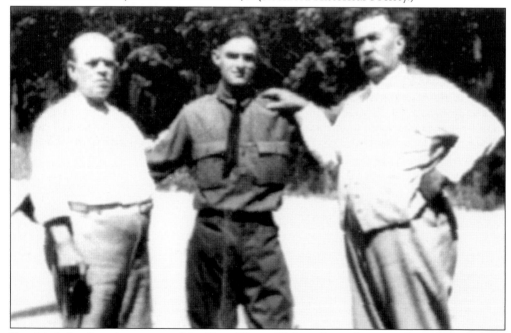

Bert McAuley, longtime owner of the Grand River Club, is shown here at right with his brother Erasmus, left, and nephew Arthur McAuley, who fought in World War I. The picture was taken in 1918. Erasmus, nicknamed Rassey, was a Michigan state boxing commissioner. (Rockford Historical Society.)

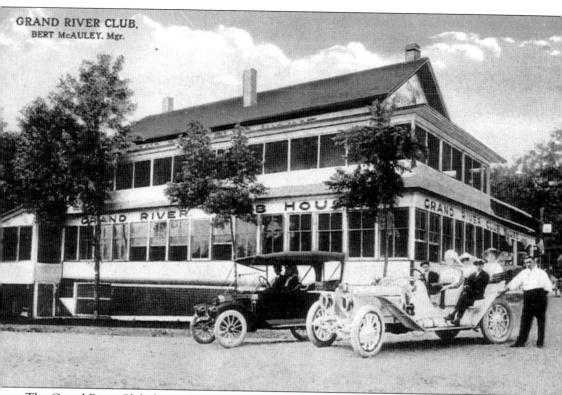

GRAND RIVER CLUB,
BERT McAULEY. Mgr.

The Grand River Club, located along the Plainfield-Sheridan wagon trail (U.S. 131 and River Road) was owned and operated by longtime Plainfield Village resident Bert McAuley. He started the business in 1896 and incorporated in 1897 as the Grand River Club. Formerly a stagecoach stop, tavern, and hotel, the Grand River Club building was now host to a growing number of members and friends, often the most influential members of Grand Rapids society. These folks often raced horses along the River Road to the club or in winter used sleighs. Prohibition put a damper on the festivities at the Grand River Club, although the restaurant, well known for its chicken dinners, did well. McAuley closed the club in 1923 and sold the property to the Kent County Road Commission, which straightened a sharp curve in the road and created part of the new road. A portion of the property is now part of Blythefield Country Club. (Rockford Historical Society.)

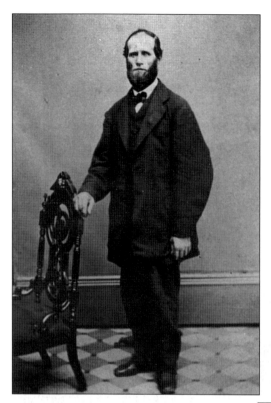

Joseph TenEyck came to Plainfield Township via Flint around 1855 and operated a general store and perhaps the post office at Austerlitz. He married Hepsy Filkins in 1866. Hepsy and Joseph lived on an 80-acre farm at the northwest corner of Kuttshill Drive and Rogue River Road. (Plainfield Township Historical Society.)

Hepsy Filkins TenEyck was born in 1847 in Groveland, New York, the only daughter of Elijah and Mary Brownell Filkins. Her three brothers, Edward, Charles, and Jared, all lived and were buried in Plainfield Township. Joseph and Hepsy had four children: Mary Kata, Maisy, Lydia, and John Cox. Hepsy died in 1923 after she and Joseph retired to Rockford. Joseph died in 1912. (Plainfield Township Historical Society.)

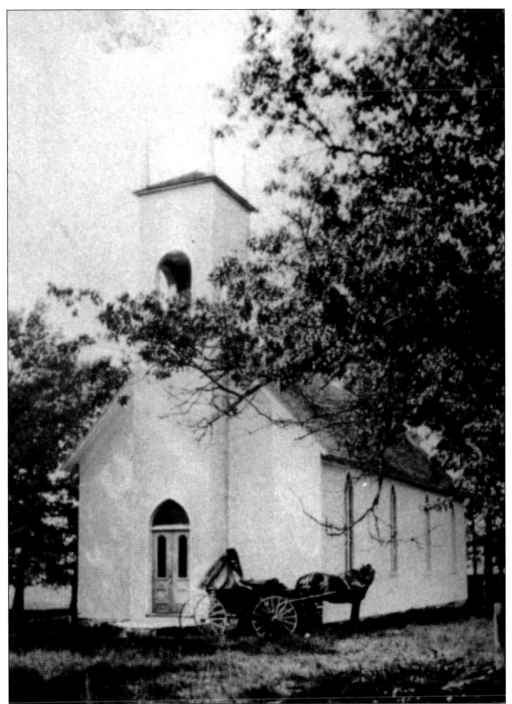

Christ Church, located at the northeast corner of Cannonsburg Road and Northland Drive, was erected in 1851 as the Reformed Episcopal church; it was later used by a number of denominations through the years. Services were conducted until 1864, when they were discontinued, with the reorganized church opening in 1873. Dr. William Hyser's horses grazed the property during the years the church was closed. (Plainfield Township Historical Society.)

Christ Church, which operated under a variety of names, alternated between use by a variety of denominations and standing empty until Joseph Brewer acquired the property in 1923. In a dispute over rent with the Free Baptists, the church was permanently closed, sitting empty except for the occasional wedding. The church was eventually converted to a storage barn for farm machinery and then stood empty once again until it was destroyed by arson in December 1970. (Grand Rapids Public Library.)

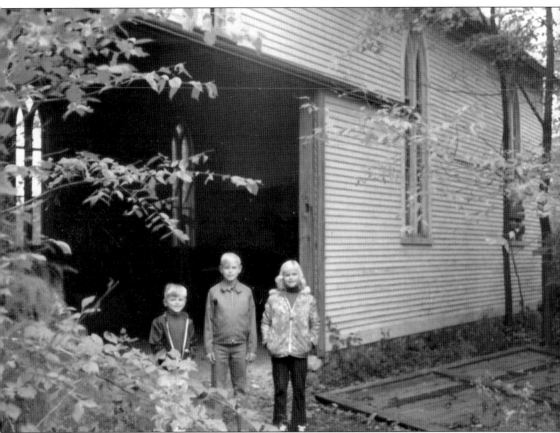

Christ Church stood empty for years. Leonard Versluis turned the church into a storage building when he purchased the property, adding a sliding barn door for easy access. In 1986, Andy Dykema bought the property from Grand Rapids Gravel, which had purchased it from Versluis in 1966. The church burned as a result of arson in 1970. Shown here are Jeff, Joel, and Jayne Dykema in front of the church. The photograph was taken during a family hike. (Andy Dykema.)

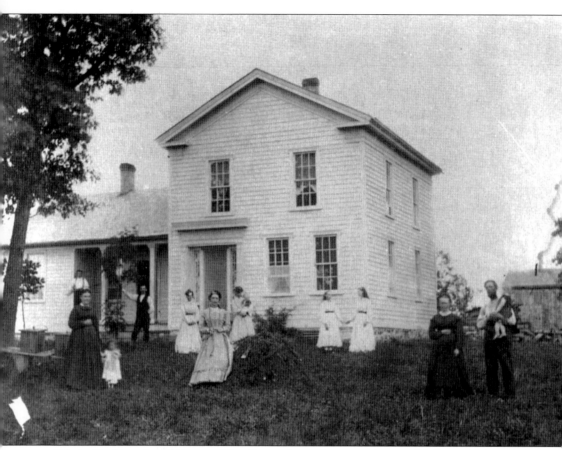

Edwin Konkle, whose house and family are shown here, was born to Hollis and Mary Sheldon Konkle in 1868. He farmed at the northeast corner of Belmont Avenue and West River Drive. Edwin was a farmer, painter, and township clerk and helped others with reading and writing tasks. Edwin married Cora Davis, with their son Lewis James born in his father's house in 1916. Their other children were Silas, Gertrude, and Lillian. Several other Konkles settled in Plainfield Township, including Elijah Konkle, brother of Hollis, and Phineas Konkle, probably a brother to Elijah and Hollis. All three came to Plainfield Township in 1839. Konkle Town was a small community built around a sawmill on the Rogue River at the west end of Plainfield Village, owned and operated by the Konkle family. This settlement no longer exists. Members of the Konkle family held the posts of township clerk, treasurer, and supervisor through 1915. (Plainfield Township Historical Society.)

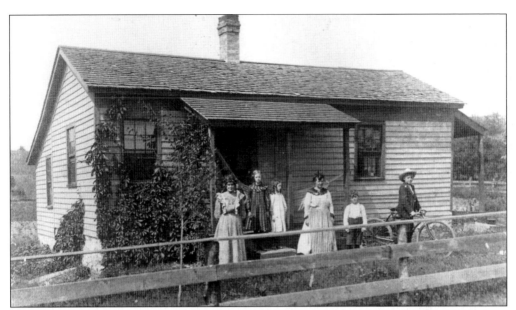

Arthur John Cadey married Rachel Seamon in 1882 and moved to Plainfield Township, to a location near the Grand River on the hill below Blythefield Country Club and near the hamlet of Austerlitz. In 1912, the couple moved to Ripley Street near the Grand and Rogue Rivers. Rachel was a nurse for Dr. William Hyser. The Cadeys had six children, shown here at the Ripley Street homestead. Sons Raymond and Arthur owned a barbershop in Comstock Park for over 40 years. (Plainfield Township Historical Society.)

Lucille Cadey was born on August 11, 1892, to Rachel and Arthur John Cadey. Lucille married Arthur Segard in 1927, and they moved to her parents' house on Ripley Street, which they had inherited. Lucille, shown at age 16, remembered sledding down Northland Drive hill when it was a dirt road and remembered attending Christ Church on the Brewer property. Lucille died in 1982 at age 89. She and her husband had one son, George, who owns the family homestead. (Plainfield Township Historical Society.)

Gilbert Heeringa was the proud owner of this hewn watering stone, the same one he used to water his horses when he brought produce to the market in Grand Rapids. He brought that produce for a farmer he worked for on West Bridge Street, now known as Lake Michigan Drive, in 1906 or 1907. Heeringa somehow came to own the stone, which he moved to his home at 3958 Plainfield Avenue, where it was used as a birdbath. This hewn watering stone has been displayed in the yard of the Hyser Rivers Museum, at 6440 West River Drive. (Plainfield Township Historical Society and Jim Heeringa.)

Joseph and Augusta Brewer built this mansion atop the hill at Northland Drive and Cannonsburg Road. The Brewer family lived there until about 1943 (this photograph was taken in 1944), when Augusta sold the property to Leonard A. Versluis. Joseph Brewer had died in early 1943 after years as a Grand Rapids businessman with ties to the banking and utility industries. He bought the farm as a country estate, raising purebred Holstein cattle. Brewer was the founder of Blythefield Country Club, created on land he donated. Various interests later owned the Brewer land, with a number of people living in the house until it was used as a practice burn for the Plainfield Fire Department in the early 1980s. (Grand Rapids Public Library.)

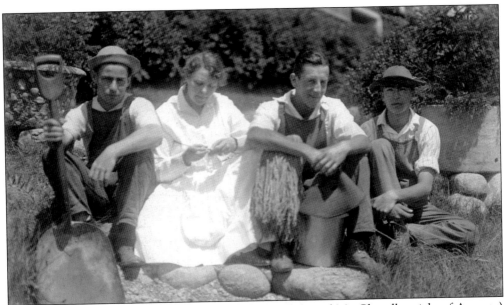

Augusta Brewer sits with two farmhands (Mr. Patton, left, and Mr. Chandler, right of Augusta) and her son Joseph Hillyer Brewer, far right, who was educated at Dartmouth and Oxford Universities. He started his career as a publisher, forming Putnam and Brewer, which was sold to Harcourt, Brace. He was president of Olivet College from 1934 to 1944. (Grand Rapids Public Library.)

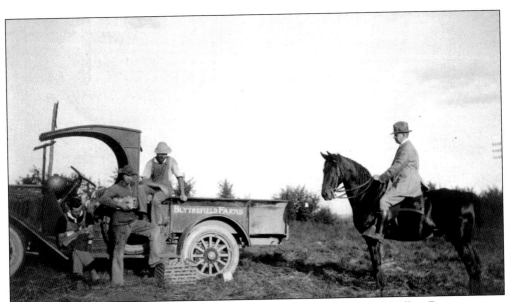

Farmhands Patton, left, and Chandler, in truck bed, are assisted by Joseph Hillyer Brewer, center. Blythefield Farms owner Joseph Brewer sits atop the horse. (Grand Rapids Public Library.)

Joseph Henry Brewer bought 1,000 acres of land north of the Plainfield Bridge in 1923 to create a dairy farm. He took out all the buildings left in Plainfield Village (except Dr. William Hyser's house) and began an elaborate landscaping project. The waterfall was created near the corner of Cannonsburg Road and Northland Drive. (Grand Rapids Public Library.)

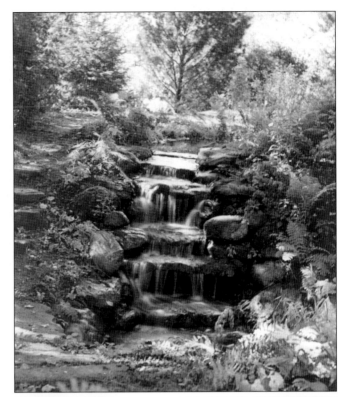

Mary Augusta Hillyer Brewer, married to Joseph Henry Brewer in 1894, liked to be called Gussie. She led the way in landscaping the Brewer property, an elaborate job that included waterfalls and many flowers. Augusta and Joseph's first son, Hillyer, died at about age three when Gussie was pregnant with Joseph Hillyer Brewer. There were no other children. She was born in 1873 and died in 1967. Augusta was the daughter of Frances Hillyer, M.D., one of the only female physicians in Grand Rapids at the time. (Grand Rapids Public Library.)

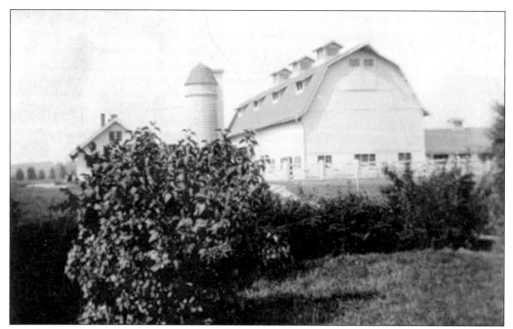

Joseph Brewer raised prize-winning cattle on his 1,000-acre farm in Plainfield Township. His huge barn was a showplace, which caught fire on a Sunday afternoon, drawing residents from across the township to watch the dairy barn burn. The year is unknown. (Grand Rapids Public Library.)

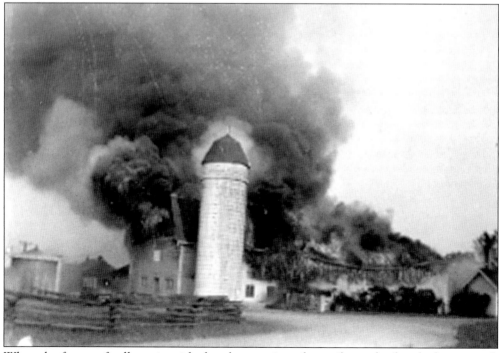

When the fire was finally extinguished, only a portion of two silos and a few sheds remained. (Grand Rapids Public Library.)

Two

BELMONT AND
COMSTOCK PARK

As Plainfield Village flourished and then waned, two other cities in the township grew up. Belmont was located several miles north of Plainfield Village and boasted stores, hotels, a post office, and a thriving gravel pit. The town benefited from the railroad that cut through the town (originally called Whitney) on the way to Rockford and points north.

The center of Belmont life in the early days was Charles Filkins's store (brother of Hepsy Filkins TenEyck) and Isaac Post's hotel. Ben Jones later took over the store. Hotel Belmont, built by Belmont Dickerson, opened for business in 1852. Belmont is now the center of Plainfield Township life by virtue of being home to the Plainfield Township offices. Portions of the hotel still stand, although the original post office and township offices no longer exist.

Comstock Park started as Mill Creek, named after the creek that fed into the nearby Grand River, which was the impetus for several early mills. Mill Creek became Comstock Park thanks to the influence of powerful businessman Charles C. Comstock, who invested in the nearby North Park bridge. The bridge allowed visitors easy access to the town, the West Michigan State Fairgrounds, and the road that wound along the river to the north.

Business thrived thanks to the Michigan State Bass Hatchery, several tanneries, hotels, and the fairgrounds. Names such as North, Plumb, Withey, Lydell, Fink, Morrissey, and Lamoreaux became well known. Today some of the original downtown area still exists, although the mills and tanneries are gone and U.S. 131 runs through the old fairgrounds.

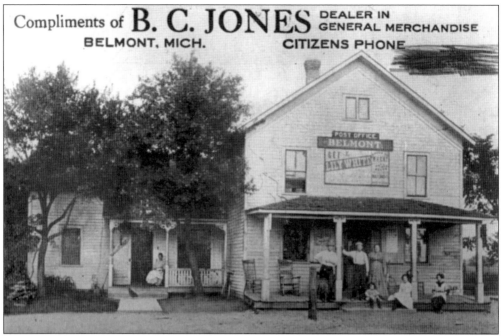

The village of Belmont was platted in 1874 and located seven miles northeast of Grand Rapids and one mile north of the Grand River. Charles Filkins, brother of Hepsy Filkins TenEyck, ran the village store, and Isaac Post ran the hotel, with Ben Jones later taking over the store, shown here. Jones was also appointed postmaster for Belmont in 1901. (Plainfield Township Historical Society.)

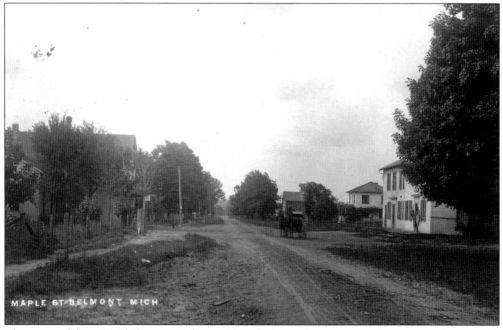

This postcard shows Maple Street in Belmont. Note the horse-drawn carriage. The postcard was mailed from Belmont to Cedar Springs in 1917 using a 1¢ stamp. (Plainfield Township Historical Society.)

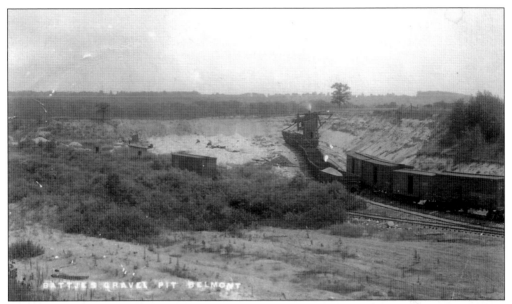

Belmont was home to Battjes Gravel Pit, shown here in a postcard sent to Grand Rapids from Belmont in 1912. The gravel pit was located at the current Rogue River Park, east of Belmont Avenue. The train track, now the White Pine Trail State Park, ran near the gravel pit. Clyde and Don Battjes, sons and nephews of the original owners of Battjes Gravel Pit, renamed and expanded the enterprise into Grand Rapids Gravel, which was purchased by Andy Dykema in 1986. (Andy and Joel Dykema.)

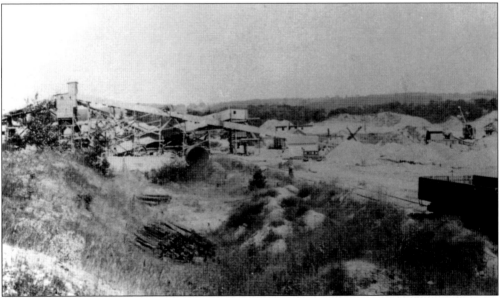

Belmont Sand and Gravel Company was one of the first sand and gravel operations in Plainfield Township. It used the former Pennsylvania Railroad tracks that ran east and north, crossing the Rogue River three times before reaching Rockford. It ran through Comstock Park, servicing the Mill Creek Tannery, and Belmont and then alongside the Childsdale Paper Mill and the small town of Childsdale. The original rail line was moved north to higher ground to keep it safe from fire. (Plainfield Township Historical Society.)

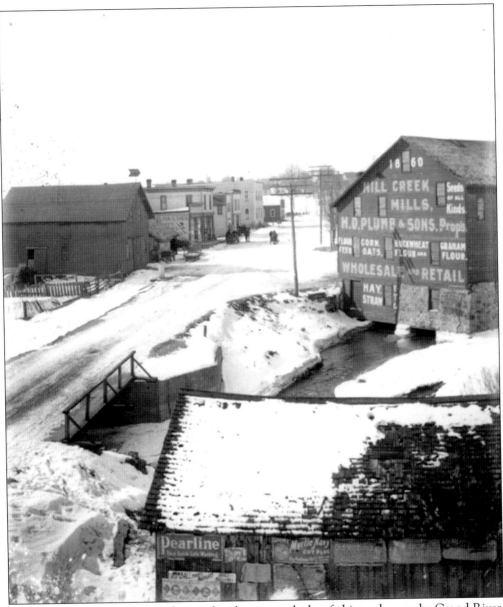

Daniel North in 1837 was the first settler along a creek that fed into the nearby Grand River, and by 1838 he had built a sawmill along that creek that came to be called North's Mill while the creek came to be called, simply, Mill Creek. The mill went through several owners, including William Withey, a competitor who bought the mill from North. Withey died in 1865, and the mill was sold to Eli Plumb. Plumb's sons Henry and A. D. called it Mill Creek Mills. In 1911, a flood washed out the milldam and destroyed the mill, although it was not until 1917 that it was torn down. The waterwheel is still located in Dwight Lydell Park. The railroads changed the face of Mill Creek, bringing more residents and business and, eventually, Charles C. Comstock. He bought large parcels of land, and eventually the name of the town was changed to Comstock Park. Comstock donated land that would become the West Michigan State Fairgrounds. Comstock Park became home to a number of well-known families such as Fink, Lamoreaux, and Lydell. (Grand Rapids Public Library.)

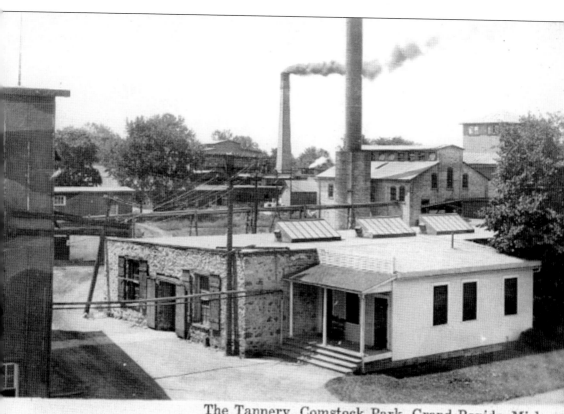

The Tannery, Comstock Park, Grand Rapids, Mich.

Tanneries came to Comstock Park around 1897. The many buildings associated with the tanneries were located north of what would become the West Michigan State Fairgrounds, with a number of railroad sidings servicing the tanneries. The tanneries closed by the 1920s and 1930s, leaving behind a number of buildings and row houses. Paul Morrissey rented parts of the Union Tannery, using one building as a showroom and another as a service shop. The tannery buildings were eventually torn down to make way for the U.S. 131 expressway. (Grand Rapids Public Library.)

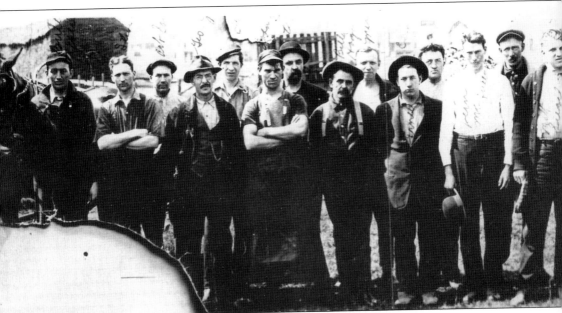

These men worked at the Mill Creek Tannery in Comstock Park; the photograph was taken in 1914. Identifications of many men were written on the photograph, but the passage of time has

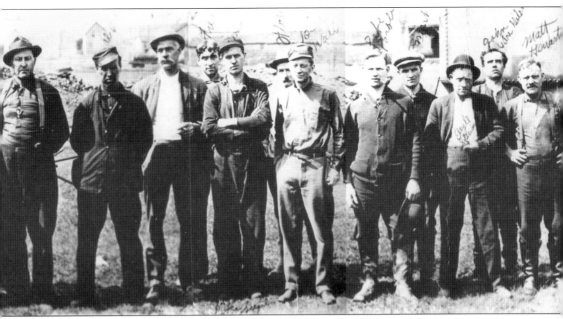

rendered these identifications unreadable. (Plainfield Township Historical Society.)

Mill Creek was home to the Michigan State Bass Hatchery, which opened in 1898 and was abandoned in 1948. The many ponds, dams, and land covered 70 acres in what was the largest hatchery in the state. The old hatchery house was built in 1897 west of the Pere Marquette railroad tracks, with the main hatchery building in 1914. The hatchery grounds are now home to Dwight Lydell Park, named after the longtime head of the hatchery. He ran it from 1896 to 1927, when he died, and his son Claude ran it from 1929 until 1948. (Plainfield Township Historical Society and David Wier.)

Nick Fink, left front, married Emily Raisch (or Rasch) in 1906 at Holy Trinity Church in Alpine Township; the bridesmaid was Mary Raisch, and the best man was Mick O'Brien. Nick Fink, whose father, Nick, settled in Mill Creek at the corner of West River Drive and Lamoreaux Drive as proprietor of the Riversite Hotel, took over the business, and ran it until his death in 1926. It became known as Nick Fink's. Emily Fink purchased the property from her mother-in-law, Katherine, and remodeled an icehouse on the property into a two-story house where she lived until her son Nick moved in with his family. Subsequent generations continued to operate the business up to the present day. (Plainfield Township Historical Society.)

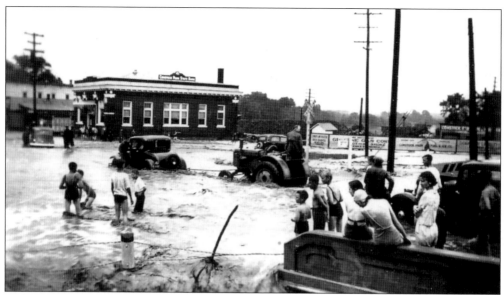

York Creek overflowed in the mid-1930s. This photograph looks northeast from the corner of Four Mile Road and West River Drive as Comstock Park residents gather. The coupe on the left is being pulled back to the bridge by a orchard model GP John Deere tractor borrowed from Morrissey Farm and Orchard Supply. The Comstock Park State Bank building is located in the near background (now Vitale's Sports Bar), with the Stites Coal Yard next to it. The fence covered with advertising signs is the edge of the West Michigan State Fairgrounds. (Paul Morrissey.)

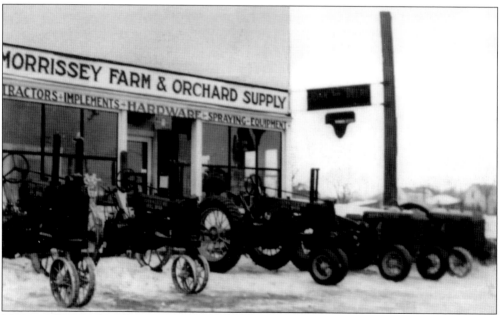

Morrissey Farm and Orchard Supply was first located in the Stowell building in 1933 at the corner of West River Drive and Four Mile Road. This was the last year of steel-wheeled tractors, shown on the left here, and the start of the rubber-tire era. This building stood where the American Legion hall is now. Note the windowless upper level of the building. (Paul Morrissey.)

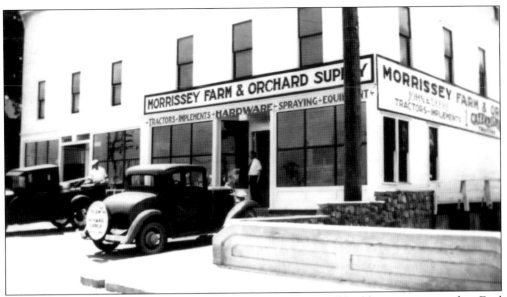

By 1934, windows were installed in the upper story of the Stowell building to accommodate Fred Lamoreaux and his band, which held dances there. Campbell Lumber had not yet rented the store to the south of the Morrissey store. The little coupe was Morrissey's sales car for calling on farmers. The bridge to the right goes over York Creek along Four Mile Road. (Paul Morrissey.)

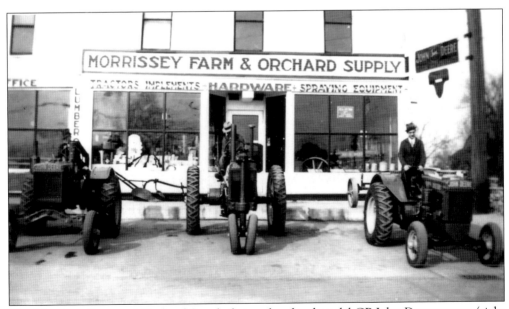

The Morrissey Farm and Orchard Supply featured orchard model GP John Deer tractors (right and left) and one tricycle farm model (center) in 1935. Notice the horse-drawn plow in the background and the windows above. (Paul Morrissey.)

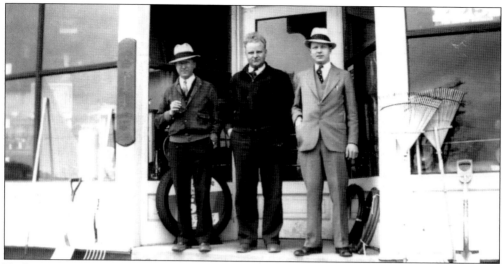

Fred Lamoreaux (center) flanked by Paul V. Morrissey (right) and Paul's younger brother Jim Morrissey stand in front of the Stowell building where Paul Morrissey opened Morrissey Farm and Orchard Supply in 1933. Fred used the upper stories of the building for dances featuring music by his big band–sound band. (Paul Morrissey.)

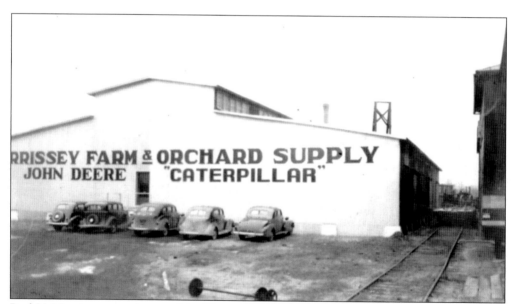

Paul V. Morrissey rented part of the Union Tannery for Morrissey Farm and Orchard Supply in 1936, buying it in 1942 along with the remaining tannery buildings, including 17 "Tannery Row" houses. Morrissey used the tanned-hide storage building for a showroom and office, while the attached building served as a shop. The heavy equipment branch of the company closed in 1966 when U.S. 131 was routed through the location of the showroom. Paul J. Morrissey built a cement block building on the remaining property and continued in the business until its sale in 1990. (Paul Morrissey.)

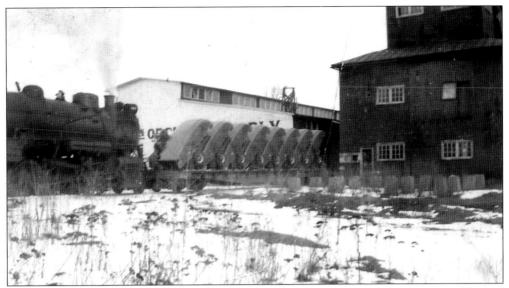

Heavy equipment like these 12-A John Deere combines, shown in 1937–1938, was delivered to Morrissey Farm and Orchard Supply on rail lines originally used by the Union Tannery. Equipment was unloaded via the tracks next to the building. Most tractors arrived in boxes and had to be assembled by hand. In 1939, Paul V. Morrissey became the first retail dealer for the Simplicity garden tractor line. (Paul Morrissey.)

Construction of the U.S. 131 expressway northbound lanes required the destruction of the Morrissey equipment building. The building, which once belonged to Union Tannery, is shown here along with the rough grade, which would become 131's southbound lanes. The building sat on hundreds of 11-foot cement pilings because of the deep muck in this area due to its proximity to the Grand River. The highway department replaced the muck and pilings with sand, much of it from Nick Fink Hill just across West River Drive. The Speedway gas station at 4121 West River Drive Northeast stands on the site of Nick Fink Hill now. (Paul Morrissey.)

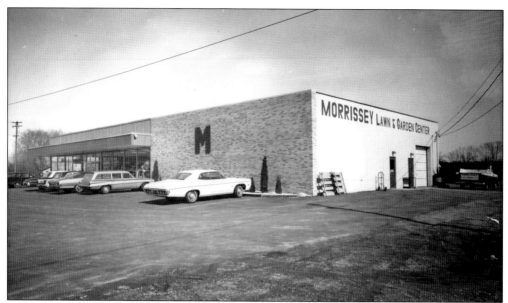

Paul J. Morrissey, third child and only son of Paul V. Morrissey, opened Morrissey Lawn and Garden Center at 3637 Plainfield Avenue in December 1960. He later moved the business south of Four Mile Road to 3131 Plainfield Avenue at the U.S. I-96 expressway. Morrissey Lawn and Garden Center continued until its sale in 1990. Paul J. retired in 1990 at the age of 89 but stayed active until his death in 1997. The building at 4050 West River Drive now houses the Outback Fence Company. (Paul Morrissey.)

When Morrissey Lawn and Garden Center outgrew the location at 3131 Plainfield Avenue, the operation moved into the Pier Marine Building at 3838 Plainfield Avenue, now adjacent to the VanAndel and Flikkema car lot. In 1968, a final move was made back to Comstock Park into a new building where Morrissey sold Simplicity, Toro, and Lawn Boy along with specialty items like electric cars and garden tractors, six-wheel ATVs, and fireplace inserts. (Paul Morrissey.)

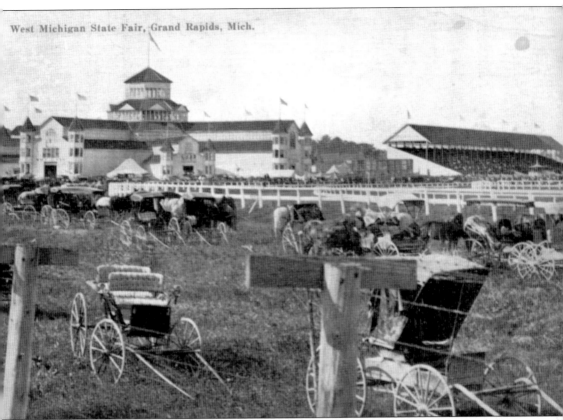

West Michigan State Fair, Grand Rapids, Mich.

The West Michigan State Fairgrounds, donated by Charles C. Comstock in 1890, boasted an eight-wing art hall; horse, cattle, sheep, and swine buildings; and a one-mile track for a variety of races. The fair ran until 1935, when it closed due to declining attendance and several fires, one of which destroyed the huge art hall, shown above. (Grand Rapids Public Library.)

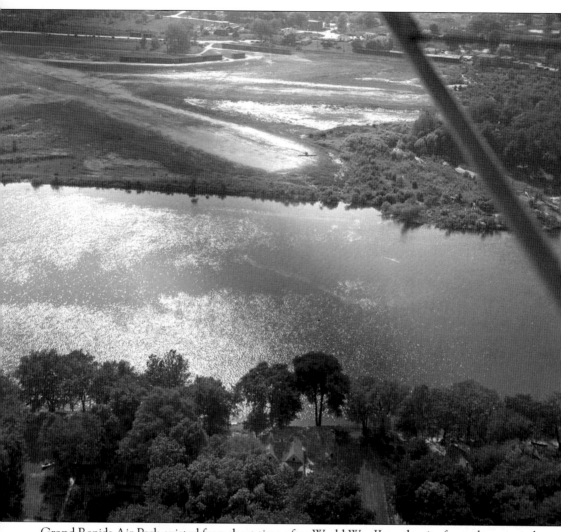

Grand Rapids Air Park existed for a short time after World War II on the site formerly occupied by the West Michigan State Fairgrounds in Comstock Park. This aerial view of the Grand Rapids Air Park was taken looking west across the Grand River. The landing strip runs northeast from Comstock Park. (Grand Rapids Public Library.)

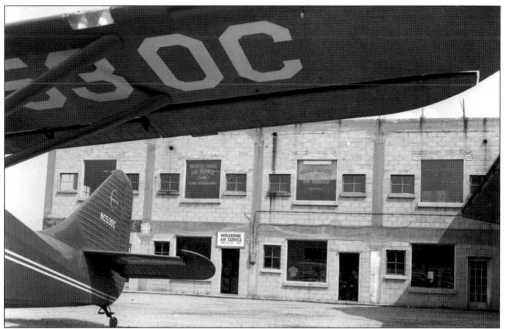

Flying businesses such as North Park Air Service, Grand Rapids Air Service (said to have been owned by Jay VanAndel and Richard DeVos), and Wolverine Air Service flew out of the airport. Marian Jane Meyer Annis, who lived across the river, remembers floatplanes practicing their landings on the river and docking at the airport. The airpark was short-lived, making way for the Grand Rapids Speedrome in 1950. (Grand Rapids Public Library.)

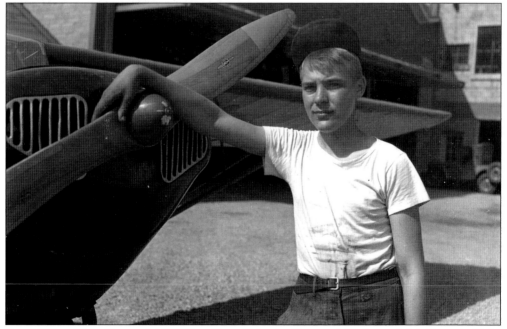

Gerald "Jerry" VanHorn, of 4415 West River Drive in Comstock Park, made his first solo flight out of Grand Rapids Air Park in June 1948. It was his 16th birthday. He received his student pilot's certificate after taking lessons from airpark pilots. (Grand Rapids Public Library.)

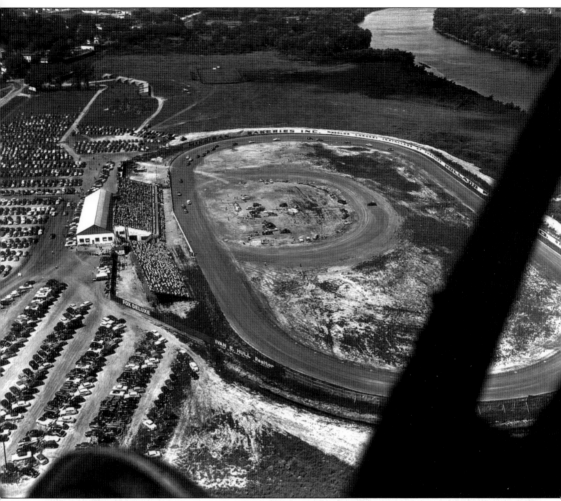

This aerial photograph of the Speedrome (looking north) shows the Grand River in the background, the outer and inner tracks, and the grandstands. Comstock Park is to the left. The Speedrome, which officially had its opening race on May 28, 1950, was not the first track on the site between Comstock Park and the river. Cars had raced there as early as 1903 at the West Michigan State Fairgrounds. Many races were held, featuring names such as Barney Oldfield, until the fair closed in 1935. (Patsy Ghysels.)

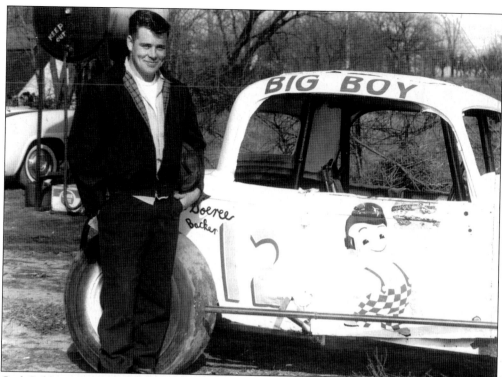

Gail Cobb, a popular driver at the Speedrome, drove the Big Boy car. (Patsy Ghysels.)

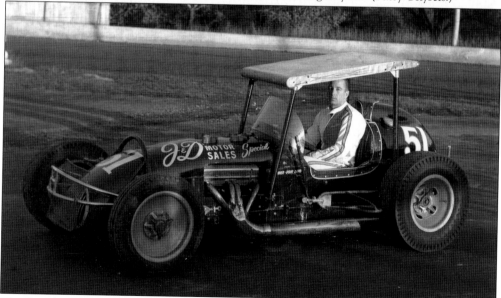

The Speedrome opened a new era by racing stock cars, a trend that replaced the popular midget cars that had been raced for years. Its popularity took off, with NASCAR coming north for a race in 1951 and Johnny Benson Sr. racing at the Drome. In 1965, the U.S. Air Force sponsored a race that drew 9,000 fans; also in 1965, Dick Carter was killed in a tragic crash, as was his friend Jimmy Nelson one week later. The State of Michigan purchased the land in 1966 for U.S. 131, and the Speedrome closed forever. Shown here is driver Norm Brown. (Patsy Ghysels.)

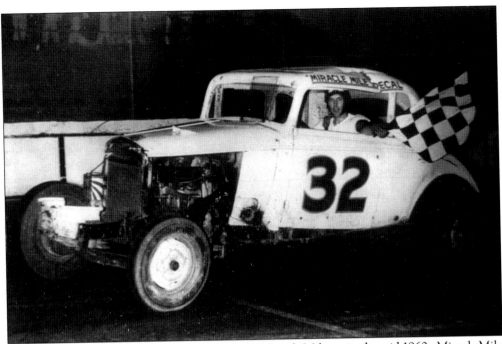

Popular Speedrome driver Duke Melinn drove the Miracle Mile car in the mid-1960s. Miracle Mile became Arlen's, which became Meijer Thrifty Acres on Plainfield Avenue. (Patsy Ghysels.)

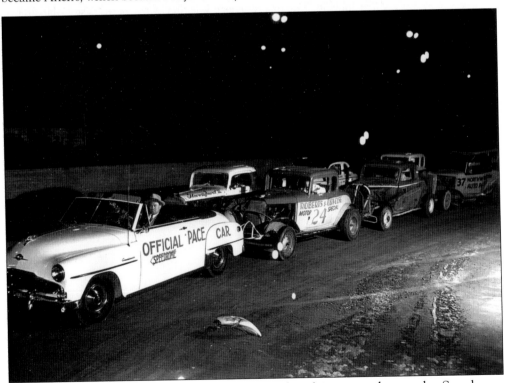

The official pace car leads the way to begin a night of racing at the popular Speedrome. (Patsy Ghysels.)

Three

TOWNSHIP FAMILIES

Family has always been part of the fabric of Plainfield Township. Many settlers hauled their house goods and children from the East Coast, while others simply got tired of the city of Grand Rapids and moved north. Whether coming from near or far, family was vital. Many had numerous children, and many lost children to stillbirth, disease, war, and accidents. The first birth recorded was that of Cornelia Friant in 1838; the first deaths were the infant twins of George and Ann Miller in 1838. The first marriage was that of the twins' sister Margaret to William Livingston, also in 1838.

Some of the most well-known names in township history include Friant, Jones, Brewer, Miller, Visser, North, Plumb, Smitter, Krupp, Brown, and Hyser. More recent names include Woodworth, Lamoreaux, Hunsberger, Morrissey, Heeringa, and Ranck. Many readers will recognize today's names, such as Annis, Briggs, Weldon, Finger, Pritchard, and Dykema.

All these families have one thing in common: a dedication to building and sustaining a vital Plainfield Township. Long dead or just moved in, each family is part of the township history.

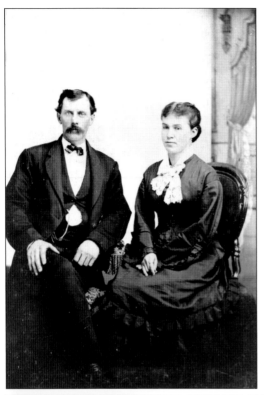

William Henry Brown, the son of Joseph and Laura Brown, was born on August 14, 1844, in Van Buren County and died in 1913. He came to Plainfield Township after serving in the Civil War and being imprisoned for a short time in Andersonville Prison. Henry met his wife, Sarah McKellan, in this area. They had three children: William Lewis (1875), Charles (1879), and Bessie (1881). The Brown children attended the school north of the Grand River on the property later owned by Joseph Brewer, and the family attended Christ Church in Plainfield Village. (Plainfield Township Historical Society.)

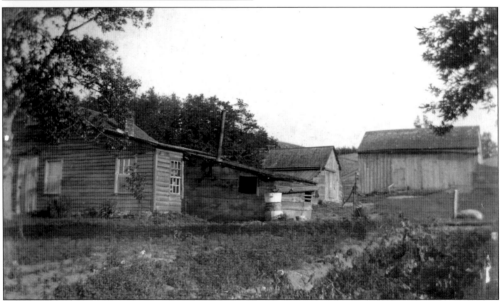

William Henry and Sarah Brown bought this farm at the foot of Rock Hill on Plainfield Avenue near Coit Avenue. They later acquired a home at the corner of Quimby Street and Coit Avenue. William Lewis, their eldest son, was born in a log cabin on what is now Hunsberger Avenue. He and his wife, Clara, bought a farm on Plainfield Avenue near the top of Rockhill, across from what is now Five Mile Road. He later owned a gas station at Plainfield Corners near Plainfield Ridge. (Plainfield Township Historical Society.)

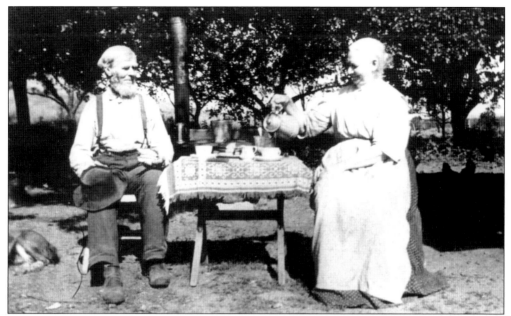

Jurrien and Egberdiena Van Dellen enjoy an alfresco lunch on their farm in this photograph taken in July 1914. Jurrien came to the United States from the Netherlands in 1869 at age 25. He returned in 1872, bringing back with him to the United States a party of immigrants including Egberdiena Smitter, whom he married in 1872. She died in 1922, and Jurrien died in 1935. (Plainfield Township Historical Society.)

The Jurrien Van Dellen family lived in Plainfield Township beginning in 1874, when he purchased land on Grand River Drive next to the Smitter property. This picture was taken around 1910. From left to right are (first row) Jessie, Elizabeth, Egberdiena Van Dellen, Bertha (foreground), Jurrien Van Dellen, and Anna; (second row) George, Margaret, Jacob, John, Fannie, and Cornelius. (Plainfield Township Historical Society.)

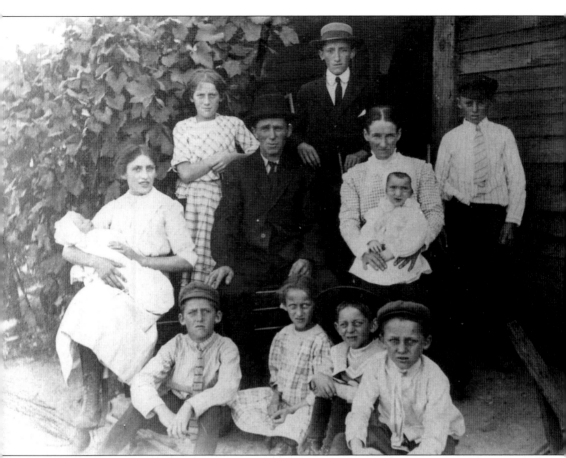

Gerrit Van Den Hoven was born in 1869 in the Netherlands. He became engaged there to Cornelia Bolle, but before they married he came to Michigan in 1891. On January 20, 1893, Cornelia and her family arrived in Grand Rapids. They were met by Gerrit, and he and Cornelia were married that same day. The newlyweds worked at various farms around Grand Rapids before moving to Plainfield Township in early 1902, having purchased land at the southeast corner of Five Mile Road and Plainfield Avenue. Gerrit and Cornelia had 10 children, shown here in 1913. From left to right are (first row) Leonard (1902, the first of their children born in Plainfield Township), Maude (1905), Abe (1906), and Joe (1903); (second row) Cora (1895) holding Martin (1913; Martin died of pneumonia in infancy), Gerrit, Cornelia holding Cornelia (1911), and Neil (1901); (third row) Mary (1899) and Orie (1897). All the children attended Oakview School on Woodworth Street, and it was during their school years that they shortened their name to Van Hoven. Gerrit died in 1939 and Cornelia in 1947. Their home, called the "old black house," was moved in 1928. (Plainfield Township Historical Society.)

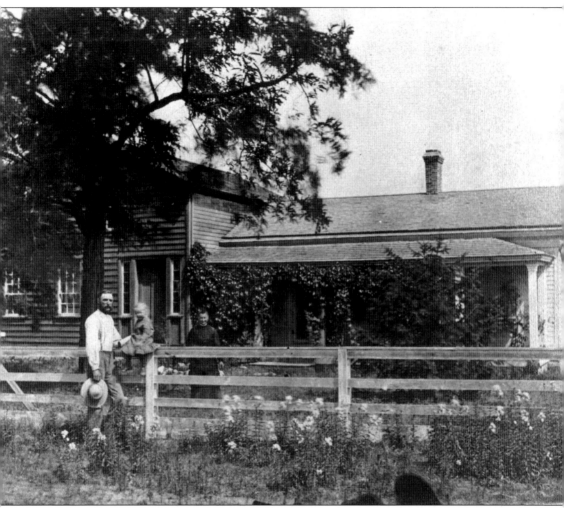

John and Mary Hartung Weller lived in Ann Arbor before moving to Plainfield Township in the late 1800s. Their farm was located on Brewer Road. Mary died in 1909, and John died in 1927. The Wellers had three children: Lucius (1868–1921), Morton (1879–1913), and Olivia (1884–1976). In 1920, Olivia Weller married Isaac Visser, son of Roelof and Grietje Broekema Visser. Isaac and Olivia bought land on the East Beltline across from what became the Grand Rapids Gravel Company. Isaac farmed in his early years but became custodian of Plainfield School, now the Plainfield Senior Center, close to his home. The Vissers' only child, Merlyn, was killed in January 1945 in Luzon at age 19. (Plainfield Township Historical Society.)

Jacob Post Sr. arrived in Plainfield Township in 1846 with his wife, Mary, eight sons, and two daughters. The family settled at what is now the northwest corner of Post Drive and U.S. 131. Seven of the sons married and settled around the Post Drive and Pine Island Drive area. Four generations of the Post family are shown here. Samuel Post, one of Jacob's sons, is at far right. Samuel and his wife, Fanny, settled at 7288 Pine Island Drive and had three sons. Samuel's son Frank is pictured at left; he and his wife, Clara, had seven children, including Leon, above, whose daughter is Crystal, below. (Plainfield Township Historical Society.)

In 1855, Conrad and Mary Jane Ireland House, with their son Alonzo (1850), built a home on a farm in Plainfield Township on what would become Nine Mile Road. Of four more children, two died of plague. Conrad farmed for 24 years before moving to Belmont to live with his daughter Linnie Cranmer. Conrad's son Charles farmed the homestead. Alonzo, or Lonnie, bought adjoining land. Lonnie married Eva Andrus in 1870, and the couple had a son, Arthur (1874), and a daughter who died in infancy. Eva died in 1876, and Lonnie married Anice Thorpe in 1878. Anice bore four children: Clifford, Elwin, Mable, and Luella. Clifford farmed with his father until 1924, when he became a mail carrier. Pictured are Ray E. House Sr. (left, born in 1904), Alonzo (seated) holding Ray House Jr. (1924), and Arthur (right). (Plainfield Township Historical Society.)

Cyrus (right) and Nancy Hunsberger had six boys—Glenn, Lloyd, Elden, Ward, Earl, and Lorne—all born in Leighton Township. Cyrus and Nancy moved to Plainfield Township to property north of Plainfield Avenue and west of Hunsberger Avenue. Cyrus farmed his land and became active in township government; he also founded Grand Rapids Creamery. Nancy died in 1921, and Cyrus married Lena Whitford, sold part of the farm, and moved to a home in Grand Rapids. The original farmhouse still stands on Hunsberger Avenue. (Plainfield Township Historical Society.)

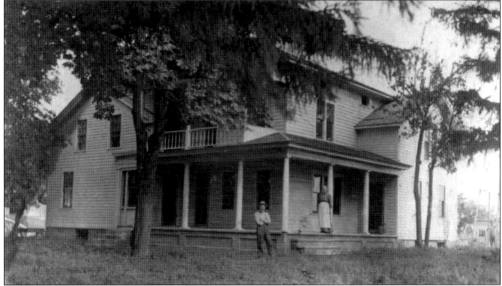

The Hunsberger sons mostly stayed close to home. Glenn married Blanche Overholt in 1910, and they raised five children at 4329 Hunsberger Avenue. Elden worked as a herdsman on Joseph Brewer's farm where he lived with his wife, Anna Cavanaugh, until around 1919, when he bought the northern acres of his dad's farm; Elden graded many of the roads in the Hills and Dales plat. Ward married Norma Huntley and lived on the homestead before moving away; he later worked on the Woodworth farm where his family lived until his death, when the family returned to the homestead. Earl married Jennie Hordyk and lived on the homestead until it was sold and became the Hills and Dales plat; he built a brick house on Woodworth Street and sold it during the Depression. Lorne married Blanche VanKovering and lived on the homestead before moving to Grand Rapids. Lloyd married and settled in Merritt. (Plainfield Township Historical Society.)

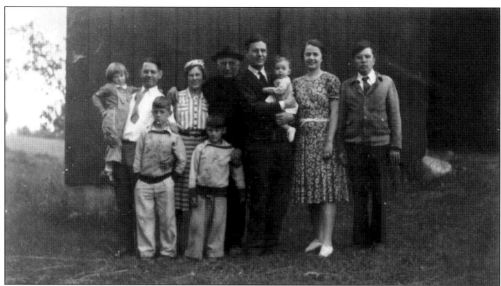

Samuel H. Ranck (center, in hat) moved his family to Grand Rapids when he became the first director of Ryerson Library in 1905; he held the post for 37 years. The family lived at 728 Prospect Street in downtown Grand Rapids and spent weekends and summers in rural Plainfield. Ranck died in 1952 at age 86. His wife, Judith, died in 1936 at age 67. The family is pictured on June 15, 1941. On the left are Joann, Charles, Dick, Betty, and Jim Hodgman. On the right are Bill, Judith Ann, and Jean Ranck and Theodore Ranck (far right). Jean was a teacher at Northview's East Oakview Elementary School. (Marj Wiltse.)

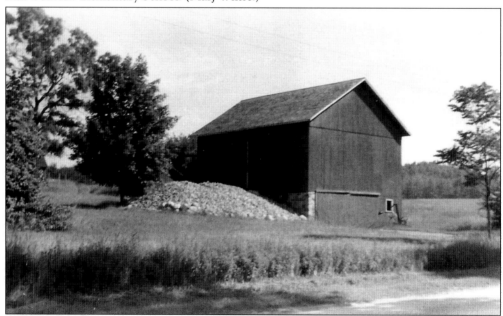

Samuel purchased the 35-acre Woodbrooke Farm at 5631 West River Drive between Buth Drive and Samrick Avenue to use as a country home. Samuel was known to walk the 10 miles from town to the farm, and the family maintained a two-acre garden near the house. Before it was torn down in the 1970s, this large barn and nearby rock pile were landmarks along West River Drive, seen in the foreground. (Marj Wiltse.)

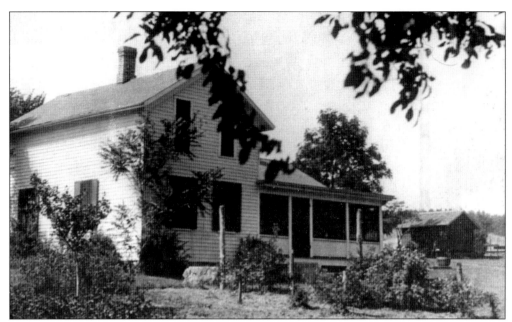

Samuel and his wife, Judith, had three children: Elizabeth, Theodore, and Wilson (Bill). Bill and his wife, Jean, and their four children—Judy, David, Philip, and Marjorie—lived on the family's Plainfield farm until about 1967, when the property was sold to the township. When Bill's family lived on the farm, the house had running water and indoor plumbing, although the well, seen here between the house and the barn, was still in use. (Marj Wiltse.)

The view from Samuel's Woodbrooke Farm included West River Drive, in the foreground, and the Grand River, in the middle. Railroad tracks ran between the road and the river. In the early 1970s, the township fire department used the farmhouse for a practice burn, with Jackson Products, Brigade Fire Protection, and Canteen Services now on the site of Woodbrooke Farm. Businesses now fill the view to the river, and the White Pine Trail State Park uses the old railroad bed. (Marj Wiltse.)

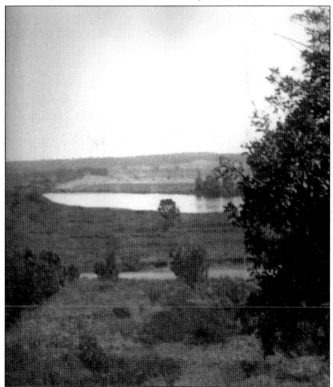

Jerome and Pauline Jost, married in 1922, bought 40 acres of land from Frank Golic in 1936; Golic had purchased his farm in 1928. The Josts built this log house at 7042 Chandler Drive from trees on the property. It was torn down in the late 1940s and replaced with a cement block house, which stands today. The youngest Jost child, Ruth Ann (pictured), bought the house with her husband in 1962 and lived there until moving to 7100 Chandler Drive. (Ruth Jost Kommer.)

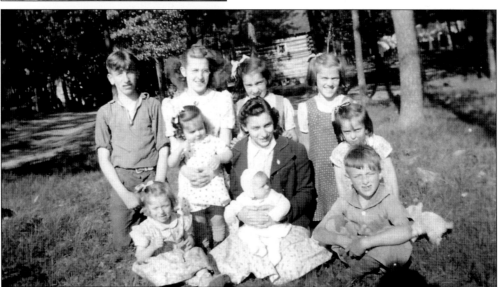

Jerome and Pauline Jost had 10 children, pictured, from left to right, here: (first row) Evelyn and Bernard; (second row) Margaret, holding Ruth Ann, and Millie; (third row) Francis (killed in March 1949 in the Philippines after World War II), Marion holding Alice, Dorothy, and Agnes. The three oldest went to Brownell School, a one-room school at Belmont Avenue and Ten Mile Road, before the family moved south. The rest attended Post School at Pine Island and Post Drives. All but the two middle daughters graduated from Rockford High School. (Ruth Jost Kommer.)

When the Jost family moved into their home at 7042 Chandler Drive, the land shown here was a hay field and part of the Golic farm across the street. Edwin and Anna Anderson bought the farm and planted pine trees in the field in about 1950. This field is now a pine forest, with no hint of its former role. (Ruth Jost Kommer.)

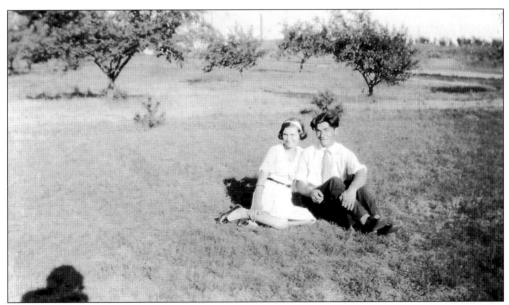

Elizabeth Swain lived at 2885 Four Mile Road, across from what is now Provin Trails, when she met Walter Schillinger, who was picking cherries at Robinette's Orchard. Walter moved to the township as a child after living in the Blodgett Home for Children. He attended fourth grade at the Plainfield School near Seven Mile Road and Northland Drive and then attended Peach Grove School through the eighth grade. After work, kids met at the end of Four Mile Road near the school. There was no East Beltline then, just a road between Four and Five Mile Roads near the orchard property, where this photograph was taken. (Walter Schillinger.)

Walter and Elizabeth Schillinger were married on June 13, 1936, at Elizabeth's parents' home in the 200 block of Seven Mile Road Northeast. Walter began work at General Motors on Thirty-sixth Street on September 18, 1936. He welded tanks during World War II. Walter and Elizabeth raised nine children: Linda Thompson, Virginia Tyler, David, Mary Cantrell, James, Douglas, Carol Sue Slaughter, Donald (who died in 1987), and Richard. (Walter Schillinger.)

Walter Schillinger started building his home at 5290 Plainfield Avenue in 1946. He and his young family lived in a converted garage next door while the house was under construction. That small house was torn down several years ago and has been replaced by CJ's Studio Salon. This photograph, taken in 1954, shows Plainfield Avenue in the background with fields beyond. Those fields are now home to a variety of businesses. (Walter Schillinger.)

Ralph Visser and Rose (Northouse) Visser, parents of Marion and Katherine (Kay), lived at the corner of the East Beltline and Plainfield Avenue. Three Visser brothers—Ralph, Alfred (Al, married to Rena Northouse), and Isaac (Ike, married to Olivia Weller)—owned three houses along the corridor. Ike's home was the last standing, recently torn down to make room for Arby's Restaurant. The other two stood approximately where the Taco Bell and the Plainfield Med Center are located now. The brothers were three of 10 children born to Roelof and Grietje Broekema Visser. (Maxine Pritchard.)

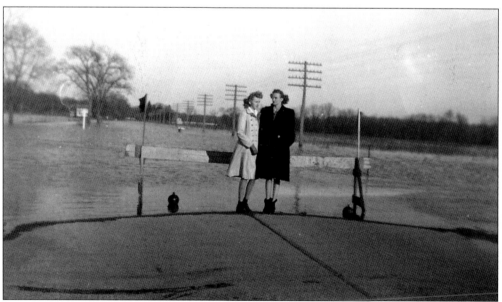

Sisters Marion and Kay Visser stand at the edge of floodwaters that cover West River Drive, then called the River Road, between Northland Drive and Grand Island Golf Course. Property on the left is about where the soccer fields on West River Drive are located today. The house on the left stands today at the corner of West River and Indian Drives. This picture was taken by Maxine Pritchard in March 1942. Kay died in 2002. (Maxine Pritchard.)

Harry and Ella Roesink moved from Turner Street in Grand Rapids to a 30-acre farm at the corner of Chauncey Drive and Cannonsburg Road in 1917. Harry bought the property from Wes Northouse, brother of Rena and Rose, who married Visser brothers. The Roesink home stood on one acre in Cannon Township, with the 29-acre farm in Plainfield. The Roesink children are pictured: Natalie, age six; Leland, age three; and Maxine, age six months. Maxine was a year old when the family moved to the farm and has lived at the corner of Chauncey Drive and Cannonsburg Road for 90 years. (Maxine Pritchard.)

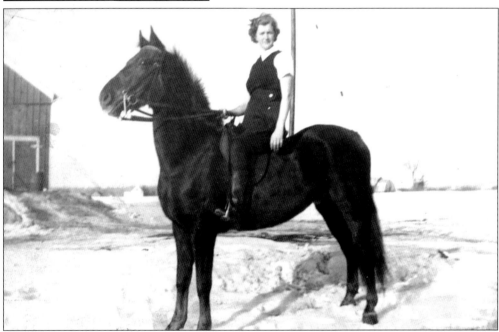

Maxine (Roesink) Pritchard rode horses on her father's farm. Here she rides Chief, owned by John VanderJagt, who owned Reliable Cartage and lived at 2576 Plainfield Avenue, south of Three Mile Road. Chief won a blue ribbon at the Michigan State Fair in Comstock Park in 1940. The Roesinks also boarded a horse for Dr. M. R. DeHaan, a medical doctor and pastor who founded Calvary Church and Radio Bible Class, now RBC Ministries. Pritchard rode with Ollie Wondergem, hired by Joseph Brewer to exercise his horses. (Maxine Pritchard.)

This large barn still stands on Chauncey Drive, now part of the Mason horse farm at the corner of Chauncey Drive and Cannonsburg Road. Harry Roesink raised cattle and pigs and grew corn, wheat, and more. Roesink also kept horses on the farm. This photograph was taken in 1920. (Maxine Pritchard.)

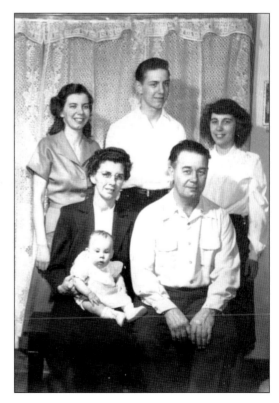

The Lee family lived in various Plainfield Township homes over the years, including the top floor of the old Homestead Restaurant at 6581 West River Drive, where this 1952 family photograph was taken. Pictured are, from left to right, (first row) Beatrice Lee, holding Marijoan's daughter Ruthie, and Harley Lee; (second row) Ruth, Larry, and Marijoan Lee Menzel. Harley worked at Blythefield Country Club, the Brewer farm, the DX gas station, and the Pennsylvania Railroad, among other places. Later the Lee family built a house in Cannon Township. Harley died in 1979 and Beatrice in 1982. (Larry Lee.)

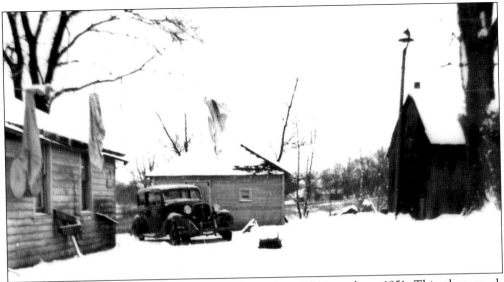

The Lee family lived at the Smitter house from about 1944 to about 1951. This photograph of the yard was taken on December 26, 1946. The Smitters settled in Section 25 south of the Grand River on what is now Grand River Drive on land purchased from Luther Lincoln in 1867. Jacob and Elsie Smitter farmed and lived at 4879 Grand River Drive with their seven children. Their son Levi (Lee) lived with his wife, Sadie Van Zalen, at 4801 Grand River Drive with their eight children, Faith and Joy (twins), Nancy, June, Ruth and Rhoda (twins), Calvin, and Carol, all of whom attended Plainfield School. (Larry Lee.)

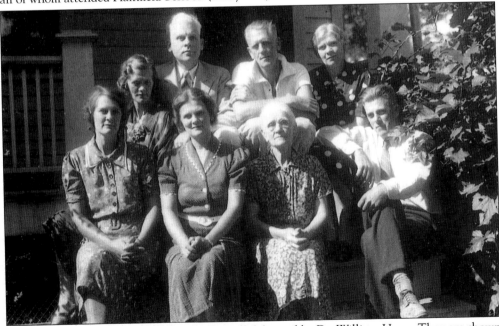

Elsie and Jacob Smitter had seven children, all delivered by Dr. William Hyser. They are shown here as adults in the early 1940s, on the Smitter farm. From left to right are (first row) Jane Smitter Buist, Lavina Smitter Newhof, Elsie Smitter, and Lee Smitter; (second row) Jacob Smitter Jr., Wessel Smitter (a novelist), and Hattie Smitter DeWaard. Rena Smitter DeWaard sits between the rows. (Smitter family.)

Ethel and Leland "Bill" Briggs built their first Plainfield house in 1928 on what was then Route 4, Leffingwell. The road became Webber Avenue in the 1930s. Electricity came in 1934, but they used a hand pump to get water from their well, drilled by John Kleynenberg, until the 1940s. The house was heated with a wood stove for years. Ethel and Bill had two sons, Edward (1926) and Wendell (1928). Note the size of the lilac bush behind the couple. This photograph was taken in the 1930s. (Louann Briggs Larsen.)

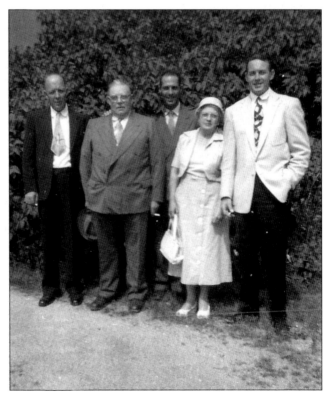

The same lilac bush appears behind the Briggs family in this photograph taken on August 15, 1958. Pictured are, from left to right, Arthur Smith (Ethel's son from her first marriage), Bill, Wendell, Ethel, and Edward. Edward started kindergarten in 1930 at Plainfield School with teacher Elizabeth Kegel. Wendell started in 1932, attending through eighth grade; he raised his family on land down the road from the family homestead. Wendell was active in township affairs. He owned a topsoil business and was active in the Michigan United Conservation Club. Wendell's daughter, Louann Larsen, bought the original family property in 1973 and lives on it now. The first homestead was used as a practice burn around 1990. (Louann Briggs Larsen.)

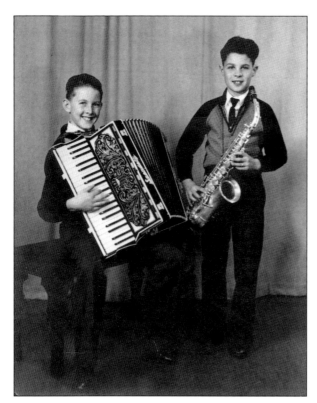

Edward, left, and Wendell Briggs played their accordion and saxophone throughout the area when they were young. Among the places were Townsend Park, in Belmont near the old hotel, and at Helen Graham's recreation center at Belmont Road and Rogue River Avenue, where the Buddhist temple is now located. (Louann Briggs Larsen.)

The Grand River was popular for swimming. These four young men are, from left to right, Ted DeYoung, Mart DeYoung, Lenny VandenBurg, and Wendell Briggs. (Louann Briggs Larsen.)

Young Wendell Briggs carved faces into the gourds on his wagon with help from neighbors Jean and Noreen Bailey, who lived on Hordyk Street Northeast, just around the corner from the Briggs property. (Louann Briggs Larsen.)

Wendell Briggs married Donna Wise in 1950 and settled on Webber Avenue down the road from the original Briggs homestead. Wendell and Donna's children are show here in about 1958; from left to right are Bill, Louann, Sandy, and Tom. Another daughter, Heidi, came along later, as did David. Tom Briggs is owner of the Grand Rogue Campground on West River Drive. (Louann Briggs Larsen.)

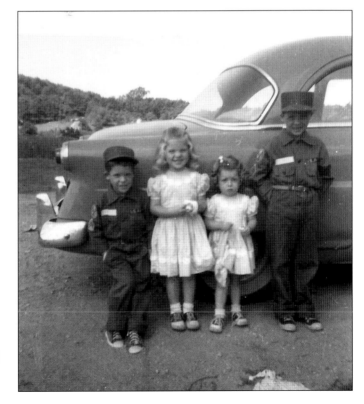

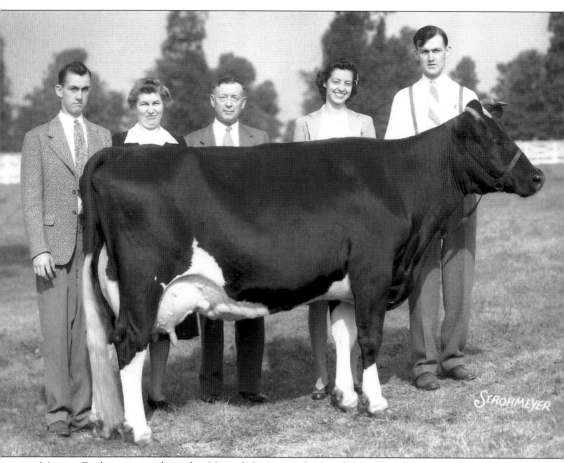

Martin Buth emigrated to the United States and Plainfield Township around 1907 to join his brothers John and Peter on their dairy farm. He bought them out and raised dairy cattle, acquiring several top-notch cows. Shown here in 1943 is Dunloggin Mistress Queen. Members of the Buth family pictured here are, from left to right, John (died in a plane crash in 1974), Allie Hodges Buth, Martin Sr., George Ann Buth, and Martin Jr. (Buth family.)

Martin Buth's son Martin Jr., born in the farmhouse at 1037 Buth Drive in 1917, ran the dairy farm until retiring in the mid-1970s. He sold the cattle in 1965 but continued to work the farm until 1975. Martin Buth III, right, and George Buth enjoy winter on the family farm, known as Creston Farms. Martin is two years older than his brother. George began his career as an attorney and is now a Kent County circuit court judge, first elected in the 1980s. (Buth family.)

Martin Buth III, right, and George Buth play on farm equipment as young boys. Most of the original 340 acres of the Buth family farm have gradually been sold; 22 acres remain today. Some of the farm is now part of U.S. 131. The original farmhouse still stands and is owned by a member of the Buth family. (Buth family.)

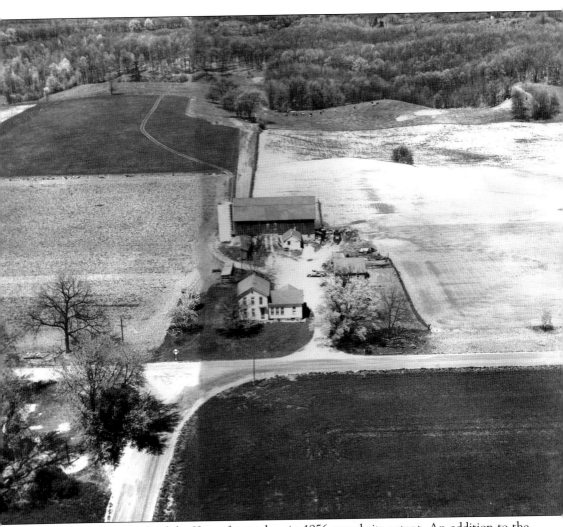

This aerial photograph of the Kroes farm taken in 1956 reveals its extent. An addition to the left of the farmhouse and a windmill have been removed, and Verna Kroes's beauty shop has not yet been built on the right near the field. George Kroes moved to the area after his parents sold their farm on Leonard Street east of the East Beltline (now Grand Rapids Golf Club) to move into Grand Rapids. George married Gertrude in the 1920s, and the couple had three children: Verna, Flora, and Leona. The land shown in the foreground, from Jericho Road to Brewer Avenue, was sold to Rockford Public Schools for $123,000. This corner is now home to the baseball fields next to Rockford High School. Land for the freshman center was purchased from Henry and Viola Schumacher, and land for Roguewood Elementary School was purchased from Cliff and Madge Alles. (Leona Kroes Benson.)

Leona Kroes, around age 12, shows off her long hair at the Kroes farm on Kroes Street. The farmhouse and barn still stand at the corner of Kroes Street and Brewer Avenue. The chicken coop at right is gone. Kroes graduated from Rockford High School in 1960 and then received a teaching degree from Western Michigan University. She retired from Cedar Springs schools in 1995. (Leona Kroes Benson.)

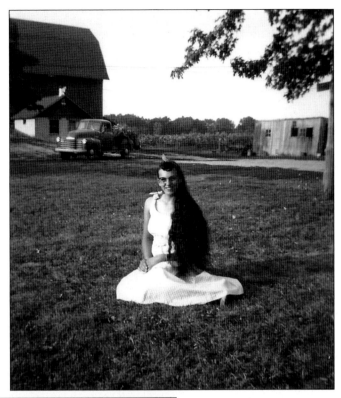

The large house at Coit Avenue Northeast was built following World War I by Captain Clarke, who became township supervisor. The driveway at that time turned off Woodworth Street, and a carriage house fronted the road; a small garage on Coit Avenue once housed a Model T. The home was admired for its open stairway with a beautiful banister and French doors opening into the dining room. Larry and Letha Mohl bought the home in June 1967 from Ronald and Alyce Meyers. The Mohl children all graduated from Northview Public Schools. The youngest son, John Mohl, and his wife, Victoria Sather Mohl, live in the house now. (Letha Mohl.)

Pictured at a Whittington family reunion, William Jones (back row, fourth from left) and Rose Whittington (seated)—married on November 6, 1891—were the grandparents of lifetime Plainfield resident Chuck Weldon. Jones's parents, John and Elizabeth, came to the Belmont area in the early 1800s. They traveled to Battle Creek via stagecoach and bought a yoke of oxen, a cart, and supplies to settle in Plainfield Township. Elizabeth's brother William Sparks owned a shingle mill on the Rogue River in Laphamville (now Rockford); William Jones was born there on March 2, 1859. (Chuck Weldon.)

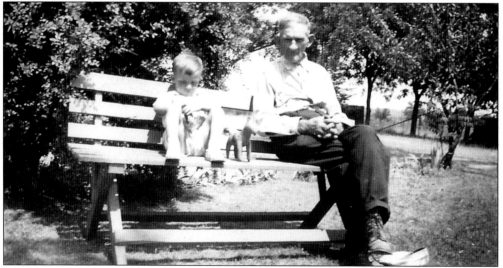

William Jones sits on a bench on his Belmont Avenue property with his grandson Chuck Weldon. Jones worked on farms and the railroad until he started the first rural mail route out of Belmont in 1902. First he carried the mail using horsepower—on a carriage in summer and cutter in winter. Jones bought a Ford Model T in 1913 but continued to use horses in the winter. He died on February 13, 1939, and his wife, Rose, died on February 13, 1953. They had four children: Ernest (1894), Linnie (1896, married to Francis Douthitt), Dena (1909), and Ernestine (1912). The Belmont Avenue house was torn down around 1954 and replaced by the township hall. The lot is now vacant. (Chuck Weldon.)

Chuck Weldon, the young boy in the center, stands with his family outside his parents' home at 6145 Idaho Avenue, located behind his grandparents' home on Belmont Avenue. Chuck was the only surviving child of Dena Jones and John Weldon (a crane operator), who married around 1928. Pictured are, from left to right, Clara Blackmer, Rose Jones, a cousin, Kreger (uncle), John Weldon, Dena Weldon, Chuck Weldon, Walt Blackmer (half brother of John), Bea Kreger (John's sister), and Minnie Traver (aunt of John and Bea). (Chuck Weldon.)

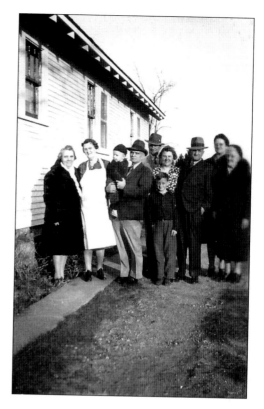

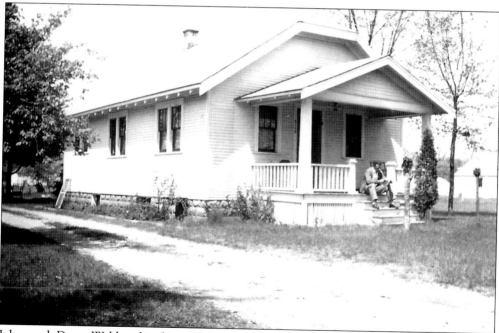

John and Dena Weldon lived on Idaho Avenue, behind Bill and Rose Jones's home on Belmont Road. The house on Idaho Avenue is still standing. John sits here on the front porch. (Chuck Weldon.)

The back-to-back property of Bill and Rose Jones and their daughter and her family, Dena and John Weldon, was the scene of much activity in Belmont. Seen here are Chuck Weldon (second from right and holding a rooster), Norm VanHeulen (left), Leonard VanHeulen (right), and a relative of the Jones family visiting from Canada, where Rose had family. (Check Weldon.)

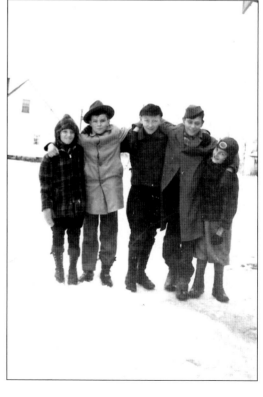

Winter in Belmont meant fun in the snow, as this picture shows. Taken on December 27, 1942, Chuck Weldon's 10th birthday, it shows, from left to right, Chuck Weldon, Bob Duchane, Norman Smith, Claude Graham, and George Koert. (Chuck Weldon.)

Charles and Mary Bissot Krupp started the farm that became known as Krupp Farm in 1916, when Charles bought the 80-acre Peckham farm. In 1919, he bought the 40-acre McDermott farm and later acquired the 40-acre Babcock farm. Charles planted an acre of strawberries in 1916, as well as potatoes, and paid off the mortgage in 1921. The farm is still located north of Nine Mile Road on what is now Krupp Avenue. Charles and Mary had two sons, Roman and Ernest. (Paul Krupp.)

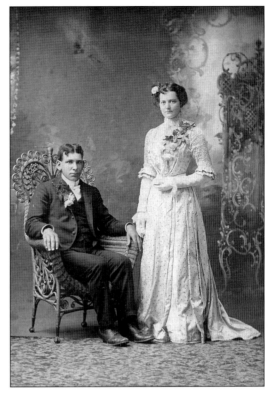

Roman and Teresa Krupp married on November 26, 1925. Roman took over his father's farm in 1944. The couple had five children—Richard, Rosemary, Teresa, Lewis, and June. Richard (Dick) and Lewis "Bud" bought their father's farm in 1966. Dick married Charlotte Jones in 1947, and they had seven children. Their son Paul bought the farm in 1990. He and his wife, Nancy Antor Krupp, also own Antor Travel. (Paul Krupp.)

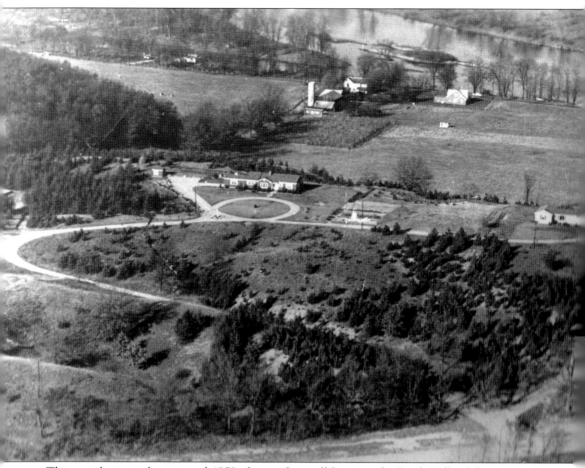

This aerial view, taken around 1953, shows what will become the Rock Hill subdivision with Plainfield Avenue in the foreground. The Grand River is in the background, along with Coit Avenue and the large farm of DeWitt Richardson, namesake of D. W. Richardson School, and the smaller house to the right that belonged to Richardson's son. The field to the right is now homes along Wabash Drive, Rock River Drive, and Danube Lane, called Riverview Meadows. Andy Dykema bought the house and Rock Hill farm from Arlo Hutt, as well as the Richardson farm, and developed the subdivisions. He starting building in Rock Hill in 1960, with the last lot finally sold in 2004. Dykema also developed the area around Highlands Middle School (off Five Mile Road), selling the school property to Northview Public Schools. While doing site work for the school in the late 1960s, workers discovered a body recently buried in one of the ruts made during the building process. No identification was ever made of the African American woman found in the mud around Highlands Middle School. (Joel and Andy Dykema.)

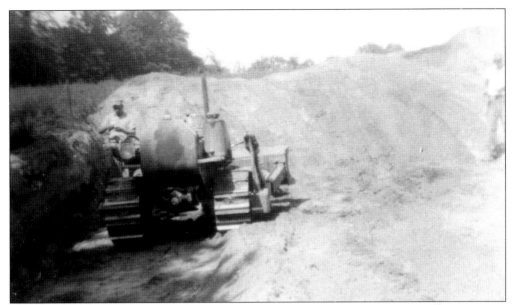

Andy Dykema started his business in 1948 at age 18. In 1950, "Andy Dykema, Excavator" used a bulldozer to dig approximately 20 basements for houses in the Hills and Dales plat, located between Hunsberger Avenue and Woodworth Street. Northview Public Schools named the nearby school Hills and Dales Middle School, now Crossroads Middle School. Here Dykema checks the grade on a basement. In 1954, Dykema dug his own basement for the home he moved into on Lester Avenue. (Joel and Andy Dykema.)

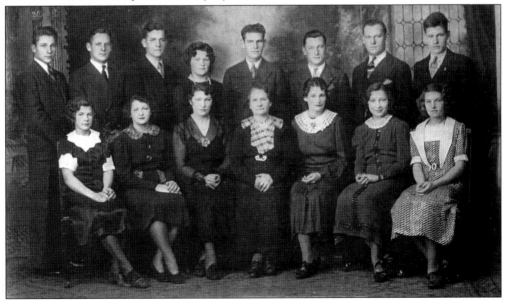

John and Mary Modzeleski had 17 children; pictured here with their mother, are, from left to right, (first row) Anne, Loretta, Jennie, Mary Modzeleski, Victoria, Helen, and Hedy; (second row) Fay, John, Louis, Marianne, Leo, Stan, Bill, and Alex. The children attended Goff School at Krupp Avenue and Ten Mile Road, although the older children attended sporadically, as they helped with farming and household work. Louis Modzeleski owned a sawmill on North Division Avenue north of Six Mile Road. (Modzeleski family.)

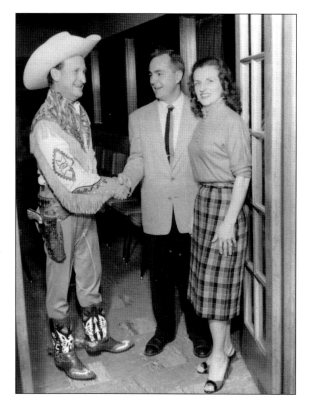

Buck Barry, who lived on Five Mile Road, hosted a Saturday morning kids' television show on WOOD-TV in the 1950s and 1960s. He starred as a pistol-packing cowboy with his horse, Thunder. He worked on a number of shows, including *Westward Ho Ho* and *Buckaroo Rodeo*, which ended in 1969. Barry retired out West and died in 1997 at age 81. He is shown here in his cowboy garb with Paul and Helen Finger. (Helen Finger.)

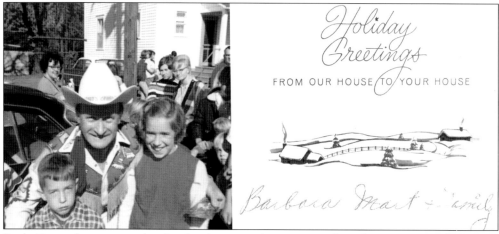

Buck Barry, long a popular local television character, made a business out of meeting children wherever they were. This photograph was turned into a Christmas card. (Dan and Nancy Burns.)

Four

BUSINESSES AND PARKS

Plainfield Township residents loved to work. They settled the land often using hard work alone. They used the natural resources of the area to develop enterprises such as sawmills, tanneries, a paper mill, and a shingle business. Even the rivers provided work as ferry drivers, boat captains and workers, and fishermen.

The business climate in Plainfield Township has been and still is diverse. A baseball stadium can coexist with a library, and an auto body shop with a restaurant. Enterprising businessmen and businesswomen have always found a way to make a living here. Bert McAuley ran the Grand River Club, Joseph Brewer ran his dairy farm, the Plumb family ran the mill, and Ben Jones ran the store. They all worked hard at what they did, often creating a successful venture.

Recreation has been vital as well, with parks and lakes dotting the landscape. Leonard A. Versluis donated a good chunk of land to create Versluis Park, now one of the gems of the township. Rogue River Park emerged from a gravel pit right in the center of the township. And the railroad, around which so many fortunes were made and lost, now is the White Pine Trail State Park, which cuts diagonally across the township from Comstock Park to Rockford. Businesses and parks have been and still are as vital to Plainfield Township as the people themselves.

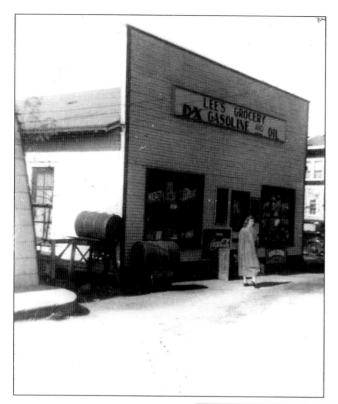

Harley Wesley Lee leased the DX Gasoline and Oil station and Lee's Grocery beginning in 1943. The family lived in the back of the store, which was located next to DeWitt's Dutch Kitchen on Plainfield Avenue. (Larry Lee.)

Maxine and Roy Pritchard owned and operated both the Sunoco gas station and Pritchard's Restaurant at 5366 Plainfield Avenue for years. Roy and Maxine met at Berkey and Gay Furniture, where Maxine worked briefly before moving to Sackner Products. They married in 1950 and had one son, Gary, in 1952. Roy closed the gas station around 1965. The couple ran the popular restaurant until 1981, when they sold it. It burned down several years later. (Maxine Pritchard.)

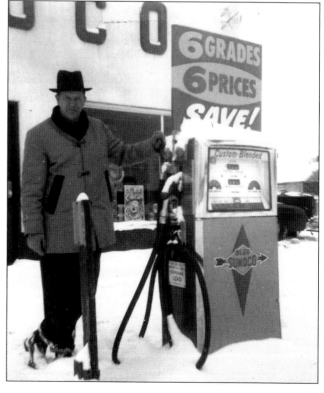

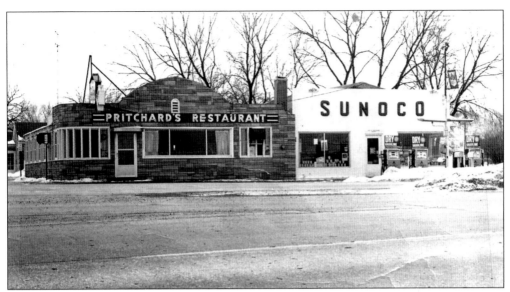

In 1948, Roy Pritchard bought the Sunoco gas station from Leo Barker. Roy's wife, Maxine, worked at Sackner Products near downtown Grand Rapids and at the gas station before the couple purchased DeWitt's Dutch Kitchen, located on the same lot as the station, where Biggby Coffee House now stands. Roy died in 1988. (Maxine Pritchard.)

Pritchard's Restaurant was a mainstay on north Plainfield Avenue from 1960 to 1981. One table was always reserved for state police officers, one for the sheriff's department, and one for workers from Wolverine World Wide in Rockford. Owner Maxine Pritchard did not allow tipping: "This is home." Pritchard holds the tub, to the left is waitress Kay Sherwood, and Maxine's mother, Ella Roesink, is at the far right in this photograph taken in 1965. (Maxine Pritchard.)

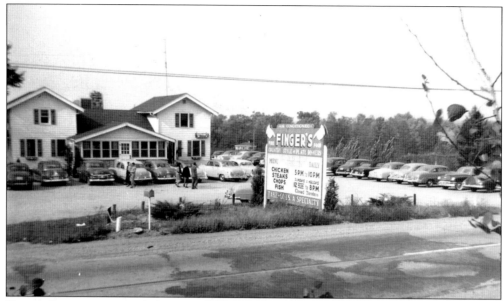

Finger's Restaurant opened along north Plainfield Avenue in April 1946. Owned by John and Louise Finger and their son Paul and his wife, Helen, the restaurant was an immediate success with its family-style service and chicken dinners. The original restaurant had been home to several restaurants before the Fingers took it over. Paul and Helen lived upstairs. They expanded the restaurant by adding rooms and turning the basement into banquet rooms, both working all jobs and just about every day. (Helen Finger.)

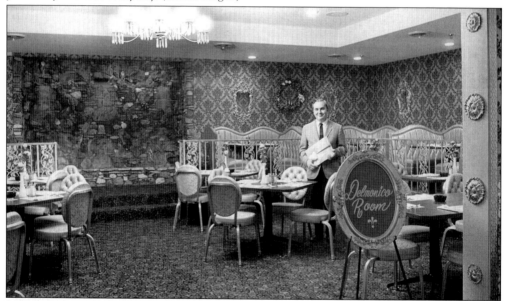

Paul and Helen Finger bought the restaurant from Paul's parents, added rooms, expanded the menu, and created a popular gathering place. The decor was luxurious as the Delmonico Room attests, shown here with Paul Finger. The restaurant could serve 600 people at one time and hosted many banquets and parties. Paul and Helen's sons Ronald and Terry took over the restaurant when their parents retired, with the restaurant closing in 1994. Paul Finger died in 2006. (Helen Finger.)

Finger's Restaurant hosted a number of famous visitors, including Gov. G. Mennen "Soapy" Williams, who stands with Ronald and Terry Finger. Other famous visitors include Rep. Gerald R. Ford, Buck Barry, Walter Slezak, and Rudy Vallee. (Helen Finger.)

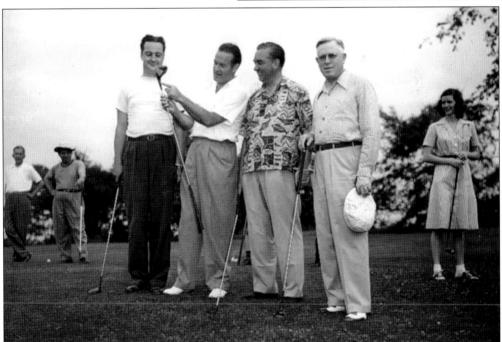

Plainfield Township hosted other famous people as well. Bob Hope, second from left, participated in one of Blythefield Country Club's many tournaments, this one taking place in June 1946. (Grand Rapids Public Library.)

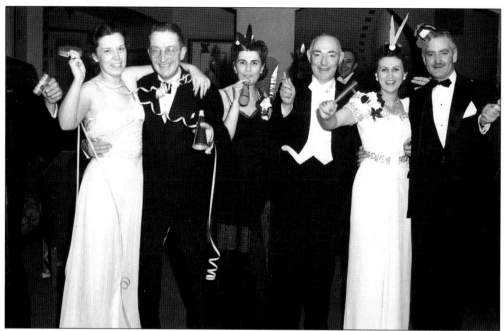

Blythefield Country Club was founded in 1927 by Joseph Brewer, who donated the land for the 18-hole, 6,850-yard golf course designed by William Langford and Theodore J. Moreau. The club's membership was filled with the top names in Grand Rapids society and hosted many a party, such as this one on New Year's Eve 1940. (Grand Rapids Public Library.)

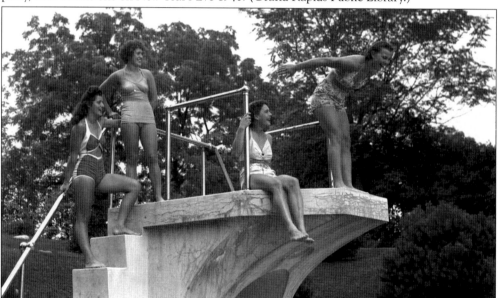

Blythefield Country Club hosted members of the famous Grand Rapids Chicks women's baseball team in July 1946. Pictured atop the diving board at the club's pool are, from left to right, Pigtail Petras, Betty "Wiggles" Wicken, Twy Shively, and Betty Whiting. The Chicks had regained first place in the All-American Girls Professional Baseball League when this picture was taken. Founded by Chicago Cubs owner Philip K. Wrigley, the league was active in the Midwest from 1943 to 1954. (Grand Rapids Public Library.)

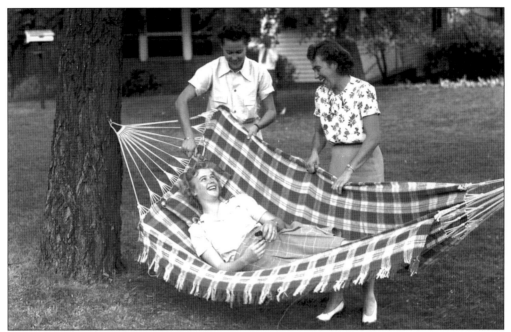

The Grand Rapids Chicks enjoy a relaxing day at the estate of Leonard A. Versluis, by July 1946 the owner of the former Brewer estate. Ruth "Tex" Lessing rests in the hammock as Silver Sloan and Gabby Ziegler look as though they are about to dump her off. (Grand Rapids Public Library.)

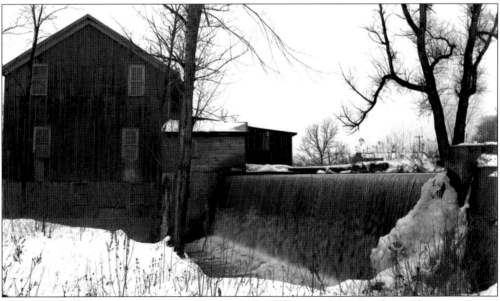

Chauncey Mill, located along Bear Creek south of Cannonsburg Road on Chauncey Drive, at one time used the power of the creek to help grind grain brought from nearby farms. This photograph, taken in December 1942, was taken before the mill became a family residence. Neighborhood children used to skate and swim on the millpond above the dam and sit in the waterfall to cool off. The Hubble family operated the mill in the 1930s. (Grand Rapids Public Library.)

Fred Pizzo emigrated from Sicily in 1958 and started a pizza business on Plainfield Avenue south of Four Mile Road in the early 1960s. He moved to the northwest corner of Four Mile Road and Plainfield Avenue in 1970, and Fred's Pizza became a north end landmark. In 1985, Pizzo tore down the house that had been home to Fred's Pizza, replacing it with a traditional restaurant building, which burned in 1996 and was rebuilt. Pizzo's son Sam took over the business in 1998. (Sam Pizzo.)

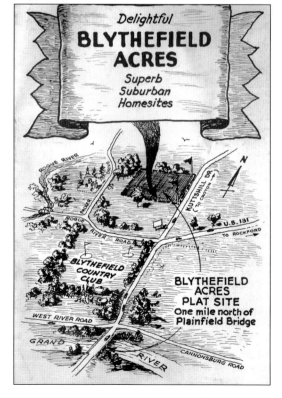

Homes in Blythefield Acres began to be sold in the mid-1950s. The subdivision was clearly much smaller then, with homes now reaching south to Rogue River Road and west to Packer Drive. Handwritten in this brochure were prices: $650 down, with a $50 discount for cash payment and a $100 discount on $2,250, with $35 a month. (Rockford Historical Society.)

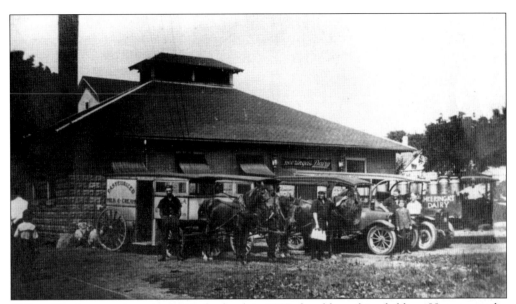

Gilbert Heeringa was born in the Netherlands in 1887, the oldest of six children. He came to the United States at age 16 in 1903 and was able to bring his family over by 1910. Gilbert married Martha Heeringa (no relation) in about 1914; the marriage produced one son, Gordon, before ending in 1921. About 1920, Gilbert took over a milk route and started Heeringa's Dairy at 1221–1223 McReynolds Avenue NW. (Plainfield Township Historical Society.)

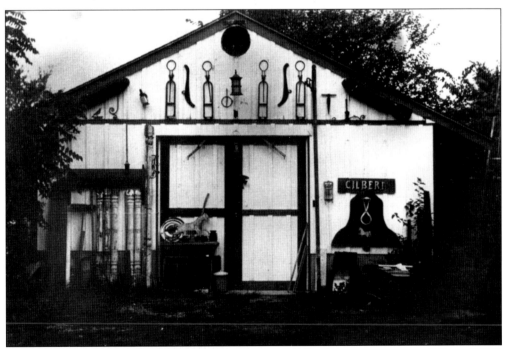

Gilbert Heeringa married Bonniebell Brandebury in 1922. Their two sons are Gilbert (1925) and Jack (1929). The family moved in 1928 to a large 1850s-era home at 3958 Plainfield Avenue, now the site of Russ' Restaurant. Bonniebell died on December 9, 1942. (Plainfield Township Historical Society.)

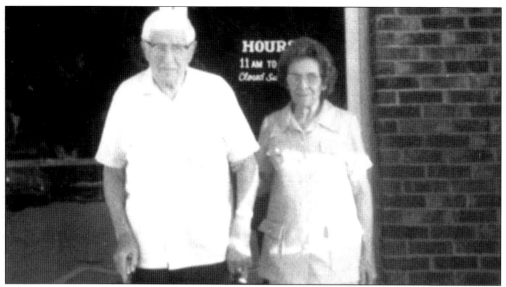

Gilbert Heeringa married Muriel T. Tiffany Green in 1947; Muriel taught Gilbert's sons at Oakview School on Woodworth Street. Gilbert served on the township planning board for more than 20 years, as well as on the Northview School Board, and drove a school bus for 10 years. Gilbert and Muriel are shown here at Russ' Restaurant. Howard DeHaan owned the Russ' franchise in Kent County and bought the property for his restaurant from Gilbert in the early 1970s; the restaurant opened in 1974. The DeHaan family still operates the Plainfield restaurant. Gilbert died in 1979 at age 91; Muriel died in 1982. (Plainfield Township Historical Society.)

Gezon Motors at 3985 Plainfield Avenue is the oldest family-owned automobile dealership in Grand Rapids, founded in 1913 by Amos Gezon, grandfather of current owner Mary Gezon Huizenga. Amos started the business at 720 Monroe Avenue with his son David moving the business north in the early 1960s. The opening was celebrated with an outdoor luncheon. Pictured are (left, from front) Gilbert Heeringa; unidentified; Violet Ketchel, and Alan Tanner; (right, from front) Ollie Hoag; Robert Mills; unidentified; Caroline Lamoreaux, and Earl G. Woodworth. (Plainfield Township Historical Society.)

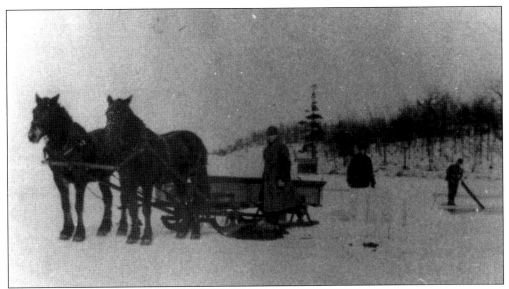

Dean Lake, called Crooked Lake in the early 1920s, was popular for swimming. This early photograph shows residents cutting ice. The VanderMolens owned and operated a large beach and refreshment stand at the end of Breezy Point Drive. By 1959 much of the lake had dried up, the bathhouse had been torn down, and many cottages had been converted to year-round residences. In 1965, residents installed a pump to restore the water level. The Dean Lake Association was established in 1966. The Michigan conservation department stocked the lake with bass in 1966 and tiger-muskie in 1968. (Plainfield Township Historical Society.)

Leonard Adrian Versluis bought the Brewer property in the 1940s and donated land south of the Grand River in 1978 to create Versluis Park, a popular swimming and recreation spot for township residents. Versluis owned the Associated Broadcasting Corporation (ABC) headquartered in Grand Rapids, and by extension, WLAV-TV, the predecessor of WOOD-TV8. WLAV-TV broadcast the first night of television in West Michigan on August 15, 1949. Versluis's ABC became the nation's fifth coast-to-coast network on September 16, 1945. (Plainfield Township Historical Society.)

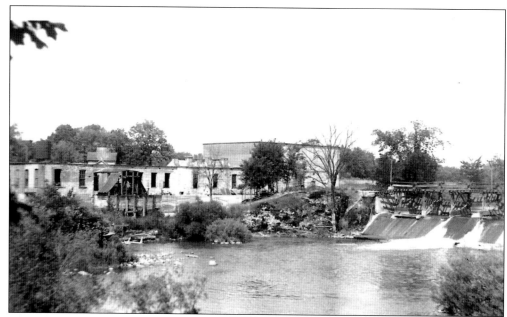

Childsdale is one of several towns in the township that no longer exists. In 1848, Amos Roberts and Zenas Windsor built a sawmill on the Rogue. The mill was purchased by Henry Childs and became prosperous. Childsdale grew up around it. Henry's youngest son Horace joined his father at the mill in 1872. In 1885, Horace took over. He married 16-year-old Frankie Lockerby and built a Victorian mansion in Childsdale. Frankie kicked Horace out after his affair with a local woman was discovered. The mill struggled, hurt by fire and the Depression; it has been revived several times through the years but has been closed since 1998. These photographs show the Childsdale Paper Mill. (Rockford Historical Society.)

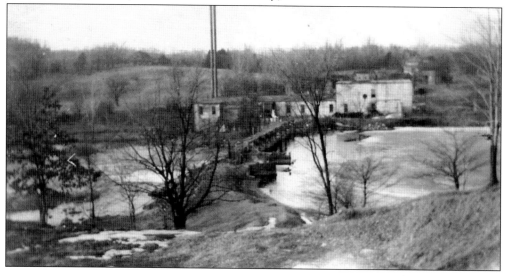

Five

CHURCHES AND SCHOOLS

One of the first things early Plainfield resident George Miller did was convert a small log building in Plainfield Village into a schoolhouse. The first public school was organized in the winter of 1837–1838. That school was the site of the meeting that led to the organization of the township.

Schooling has always been important to township residents. One-room schoolhouses sprang up as the number of residents grew, often stocked with children from the same families. Dedicated teachers helped these children, some of whom did not attend regularly due to duties at home, learn to read, spell, do arithmetic, and learn geography.

The township boasts portions of several school districts, including Rockford, Northview, and Comstock Park public schools. Private schools such as Assumption School in Belmont are important as well.

Churches also played a key role in township life. From the long-gone Christ Church to the new buildings of churches such as Assumption of the Blessed Virgin Mary and Blythefield Hills Baptist, churches continue to touch many lives.

Assumption of the Blessed Virgin Mary Catholic Church has been active in Belmont since the early 1900s, when this building was moved piece by piece from Grand Rapids. The structure, built in the 1880s, was used by St. Adalbert's of Grand Rapids until construction of their basilica was complete. After the move, it stood at 6369 Belmont Avenue until 1987, when the congregation outgrew it, and it was torn down to make room for an addition to Assumption Elementary School. Pews, windows, the bell, the baptismal font, the tabernacle, and some statues were moved into to the new church located at 6390 Belmont Avenue. (Paul Morrissey.)

Children take their first communion at Assumption of the Blessed Virgin Mary Catholic Church around 1946. Two of Stephen and Alice Burns's 10 children are pictured: Dan Burns and Bob Burns are second and fourth from right in the first row of boys. Stephen Joseph Burns married Alice McKrill in 1920 at St. Francis Xavier Catholic Church. Stephen was a firefighter in Grand Rapids. The family moved several times before settling on a 20-acre farm on the southeast corner of Ten Mile Road and Krupp Avenue. Dan Burns still lives on the original property. (Dan and Nancy Burns.)

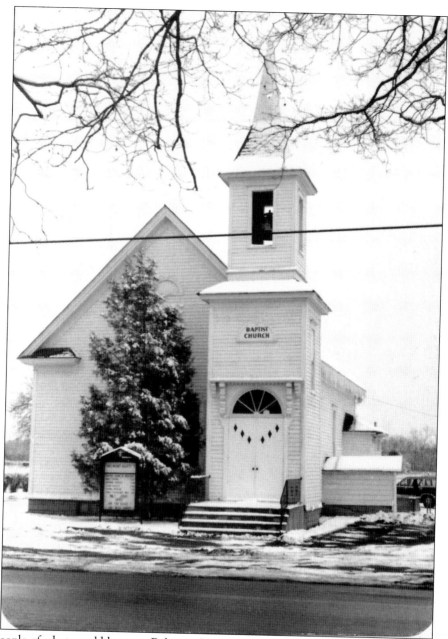

The people of what would become Belmont Baptist Church held their first services in Pinckney School and later the town hall in Belmont in about 1906. Rev. Asa Haskins was ordained a minister in the Plainfield Free Baptist Church in Austerlitz in 1907 and soon began preaching in Belmont. The first members saw the need for a church and began raising money, although not enough for a church. They heard about an empty Free Baptist church in Lisbon, a small town southeast of Sparta, and planned to buy it, but Haskins and Ollie VanDam were given the church outright at a state meeting of the denomination. The church was moved board by board, including pews and the bell, to three acres of land donated by Benjamin and Myrtie Jones, its present location. The old building was torn down in 1974, when a new facility was built just east of the original building. A large addition was recently added to that facility. (Belmont Baptist Church.)

DeWitt Richardson's father, Norman, a stagecoach driver, married Grand Rapids dressmaker Margaret Young, and they settled in Plainfield Township in 1863. DeWitt taught in the Grand Rapids area until his father died and he returned to run the farm. DeWitt served 48 years on the Plainfield School Board, and school officials renamed Plainfield School in his honor. D. W. Richardson School was incorporated into the Northview School District and was torn down in 1983 to make way for the new Plainfield Senior Center. DeWitt Richardson, shown here in 1943, died in 1963. (Grand Rapids Public Library.)

Walter and Elizabeth Schillinger's children attended D. W. Richardson School, built on the site of the second Plainfield School. This picture, taken in the winter of 1946 or 1947, pictures, from left to right, Virginia Schillinger, Sally Duverneay, unknown, Jeanette Warner, Jim Glemboski, and Dale Newton. (Virginia Tyler.)

Elizabeth Kegel, center, was the longtime teacher at Plainfield School, later renamed D. W. Richardson School. The school was first located north of the Grand River on the Brewer property and then moved to Grand River Drive west of the East Beltline. This class photograph was taken on December 20, 1928. From left to right are (top row) Kay Visser, Wynan Koning, Albert Visser, Margaret Fereda, Maxine Roesink, John Vary, and Frank Smith; (second row) James Hodges, Robert Ackenson, Betty VanZellen, Leland Roesink, Karl Vary, and Ellen Ricerow; (third row) Philip Hodges, Florence McLure, James Fereda, Margaret Hodges, Philip Hodges, and Stanley Koning; (fourth row) Lyle DeWinter, Ross Van Dellen, Jean VanZellen, Helen Brown, Lois Hodges, and George Hoekstra. (Maxine Pritchard.)

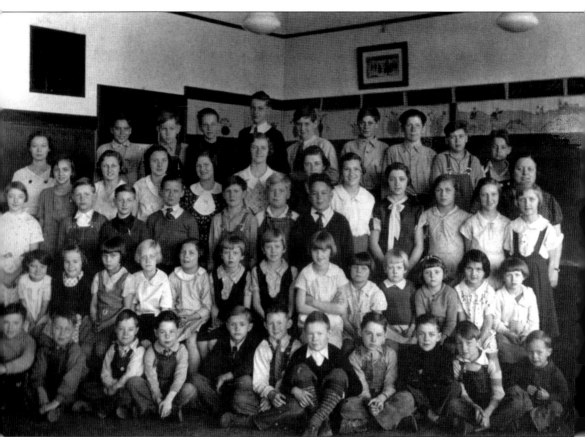

Plainfield School was originally located near Seven Mile Road and Northland Drive, just north of the Plainfield Bridge. Elizabeth Kegel was teacher there and continued to teach the students after a new school was built in 1929 on Grand River Drive. The school was built by Glenn Hunsberger for approximately $8,000. The school, also called Plainfield School, had two large rooms with a library in the middle. This photograph of the 1934–1935 students, including teacher Elizabeth Kegel (standing far right in front of back row), shows the increased enrollment. In the early 1950s, an addition was built and the name was changed to D. W. Richardson School after local resident DeWitt Richardson. The school was closed in 1978 and torn down in 1983 to be replaced by the Plainfield Senior Center. (Plainfield Township Historical Society.)

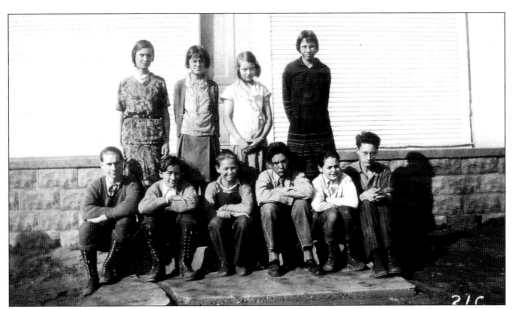

The seventh- and eighth-grade class at Peach Grove School is pictured in 1932. From left to right are (first row) Ralph Feist, John Montgomery, Edward Quist, Donald Sturgis, Robert Marek, and Robert Berg; (second row) Elizabeth Swain, Doris Swain, Margaret De Kibber, and Sadie Cole. (Walter Schillinger.)

The Oakview School District started in 1859 with meetings, votes, and committees. In 1870, the district built a one-room schoolhouse near the site of what would become Main Oakview, on land donated on Woodworth Street by Mr. Johnston. This school was used until 1923 when a new, two-room school was built. In 1929, the front section of Main Oakview was built, with additions built in 1948 and 1952. In 1959, the district served 997 students. (Northview Public Schools.)

At the end of the 1950s, Oakview School District, along with the North Park, Richardson, Peach Grove, and Atwater districts, moved toward consolidation. Enrollment in the districts totaled 2,928 students, with tremendous growth projected. An election in 1960 formalized the Northview School District, with residents voting to build Hills and Dales School, now Crossroad Middle School, and the high school building. North Park and Atwater schools were not included. Highlands Middle School was built in 1967. (Northview Public Schools.)

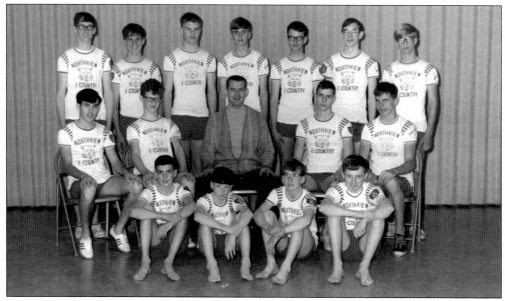

Northview High School opened in 1962, with the first graduation held in 1965. Lavern Boss was the first superintendent. In 1967, the cross-country team won the state championship, coached by Bruce Beimers, who was hired in 1962 and retired in 1990. The winning team includes, from left to right, (first row) Mike High, Allan Johnson, Dan Burnham, and Bob Fabian; (second row) Jim DeBoer, Bill Dirkmaat, coach Beimers, Don Keen, R. Cool; (third row) Wayne Wiersema, R. Cool, Bob Korstange, Mark Peterson, Dave Stoutjesdyk, Gary Anderson, and Ken Olson. (Northview Public Schools.)

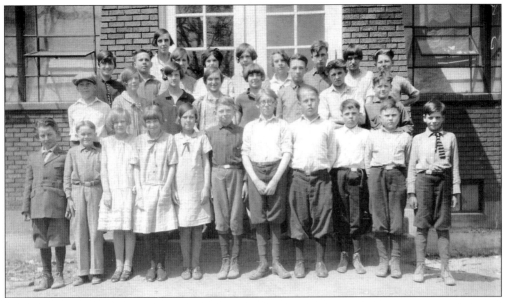

Belmont School was first built at the corner of Rogue River Road and Belmont Avenue at what is now the Linh Son Temple. By 1922, around the time this photograph was taken, the school had moved to the site of the Plainfield Township Hall, and in 1924, it moved to the present site at 6097 Belmont Avenue. Additions were built in 1947 and 1956. Central heating was added in 1953. Belmont School joined the Rockford Public Schools in 1961. (Plainfield Township Historical Society.)

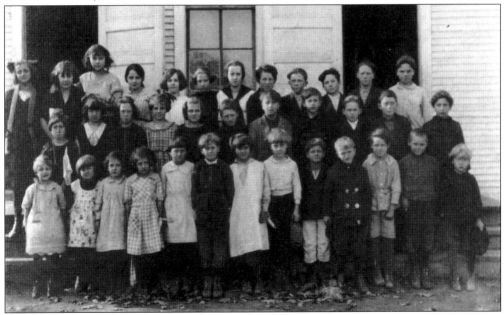

Post School, built to accommodate the growing number of families settling in the northwest section of the township, was located on property owned by the Post family. Jacob Post settled in the township in 1846, and he and his sons owned property in the Pine Island Drive and Post Drive area. The school was annexed into the Comstock Park Public School district in the 1960s. (Plainfield Township Historical Society.)

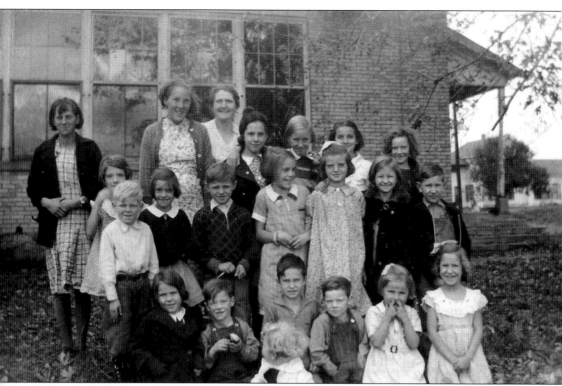

Wilson School sits at the corner of Kroes Street and Brewer Avenue between Rockford High School and Roguewood Elementary School. The school had been owned by Rockford Public Schools until its purchase by George Kroes, whose farm was located across the street from the school. Leona Kroes Benson owns the school now. The Kroes Farm is in the background of this picture of the 1937–1938 student body. Pictured from left to right are (first row) Maudie Babcock, Roger Artlipp, Harold Force, Richard Artlipp, Margaret Schuitma, and Frieda Switzer (who was killed that year at Kroes Street and Old U.S. 131); (second row) Bobbie Artlipp, Rosie Babcock, Shirley Graves, Milo Schuitma, Margaret Babcock, Evelyn Ashley, Emma Force, and Donald Switzer; (third row) Mildred Force, Verna Kroes, Hazel Beatty (teacher), Yvonne Switzer, Flora Kroes, Shirley Ashley, and Lillian Artlipp. The infant in the front is Billie Switzer. (Leona Kroes Benson.)

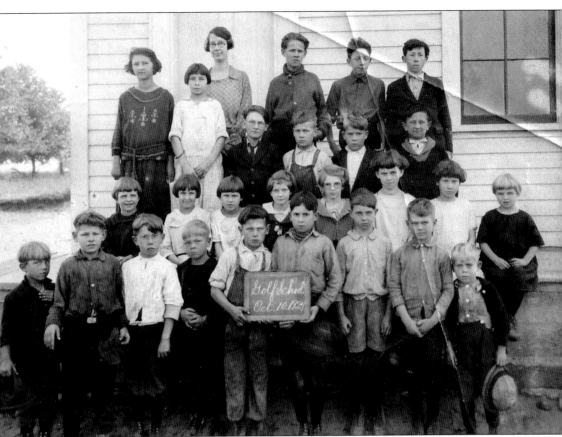

Goff School was located on the southwest corner of Krupp Avenue and Ten Mile Road, in this photograph taken in 1924. Only a few names are available thanks to some writing on the back and the census records of the time. From left to right are (first row) unknown, unknown, Joseph Fix, unknown, Stanley Modzeleski, unknown, Virgil Pickney, Leon Modzeleski, and Fabian Modzeleski; (second row) Lucille Fix, five unknown people, Eleanor Sundee, and Elsie Fix; (third row) Victoria Modzeleski, Helen Modzeleski, Arthur Gress, Claude Gress, and two unknown boys; (fourth row) teacher, John Modzeleski, Louis Modzeleski, and Elmer Sundee. (Dan and Nancy Burns.)

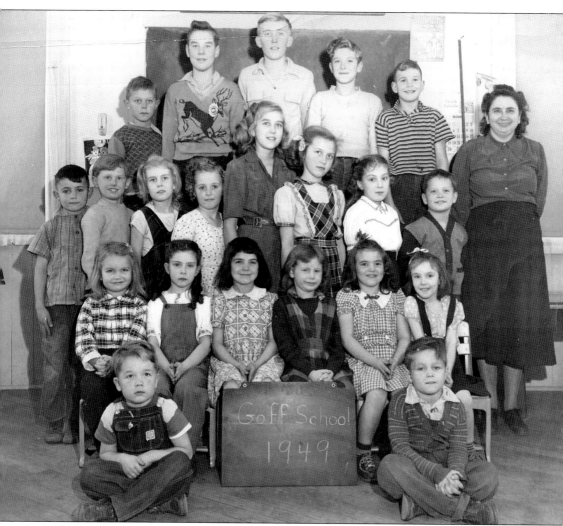

Goff School was still operating in 1949 under teacher Mrs. Kimes. From left to right are (first row) Andy Hanna and Gary Stiles; (second row) Kaylyn York, Kay Burns, Wanda Conklin, Eloise Shafer, Bonnie Bouce, and Doreen McKinney; (third row) Butch Conklin, Steve Shafer, ? Hodgkins, Patsy Stoepker, ? Hodgkins, Janet Burns, unidentified, and David Stiles; (fourth row) Melvin Stoepker, David Hodgkins, Dick Hodgkins, Dan Burns, and Ken Conklin. (Dan and Nancy Burns.)

Six

NATURAL DISASTERS

The Grand River floods its banks. The Childsdale dam on the Rogue River breaks. Snowstorms block the roads. Tornadoes destroy homes. All these and more are part of Plainfield Township history.

River flooding has clearly played a key role in township history. People expected the roads near the river to be covered with water in the spring; families expected to have to use the boat to get their children to school. In fact, flooding south of the river prevented early development of what would become the Northland Drive corridor north of Plainfield Avenue.

What folks did not expect was two devastating tornadoes in less than 10 years. The April 1956 tornado ruined homes and barns, and the Palm Sunday tornado of 1965 will be remembered by all who experienced its wrath. Towns such as Standale and Hudsonville were hit as well, with Plainfield Township in direct line for danger.

Homes were turned into kindling, animals were killed in their stalls, and families cowered in basements as winds tore up their houses above them. Plainfield Township was forever changed by these devastating events, and no township history is complete without remembering the devastation.

Marian Jane Meyer Annis grew up on Willow Drive, taking this picture in 1947 at Willow Drive and Canright Street during one of the many floods of the Grand River. The boat in the picture is the one she rode in on the way to school. Marian married Richard C. Annis Jr. in 1955, and they live in the original Annis family homestead on West River Drive. Richard Annis Jr.'s grandparents, Dr. Levi C. and Frances Beatrice Annis, lived in Cedar Springs where he was a country doctor. Their son Richard Annis Sr. moved to Plainfield Township in 1937. (Marian Annis.)

Willow Drive flooded often (as it still does today), as shown here. Marian Jane Meyer Annis remembers watching float planes from the Grand Rapids Air Park in Comstock Park practice landings on the Grand River. (Marian Annis.)

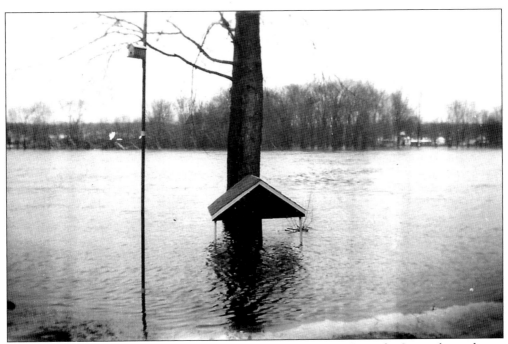

Marian Jane Meyer Annis grew up on 3785 Willow Drive near Canright Street, located near where Four Mile Road ends at the Grand River. The Grand River often flooded in the spring, as it did here in 1947. (Marian Annis.)

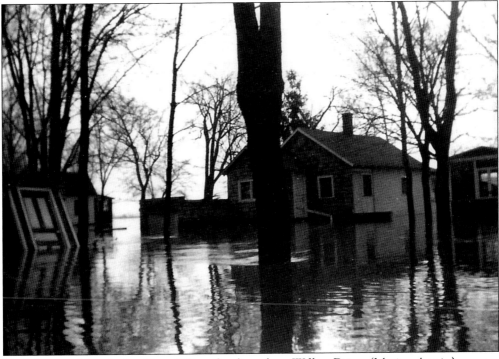

Yards became lakes during Grand River flooding along Willow Drive. (Marian Annis.)

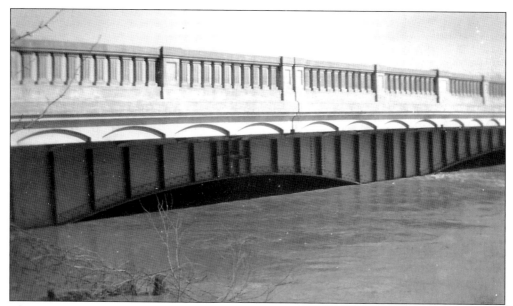

The Grand River flooded often in the spring, with spring 1942 no exception. The water reached nearly to the top of the arches underneath the bridge. (Walter Schillinger.)

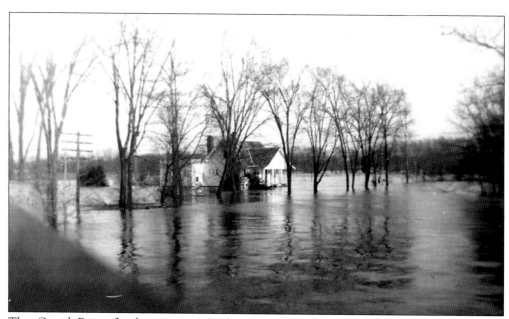

The Grand River floodwaters completely cover West River Drive in March 1942. This photograph was taken from the railroad bridge that is now part of the White Pine Trail. (Maxine Pritchard.)

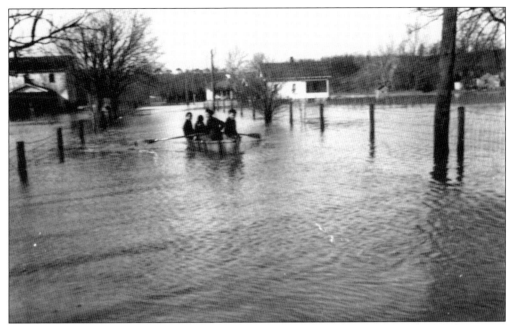

The Grand River flooded heavily in 1904, with the lowlands south of the river covered in water. The water stretched as far south as Grand River Drive, seen here, forcing residents to take to their boats to get around. (Plainfield Township Historical Society.)

A blizzard in January 1947 blocked Northland Drive near Blythefield Country Club. Snowplows had to break through the drifts to clear the way south into the city. Newspaper reports say more than 80 automobiles were backed up waiting for the plow to break a lane. (Grand Rapids Public Library.)

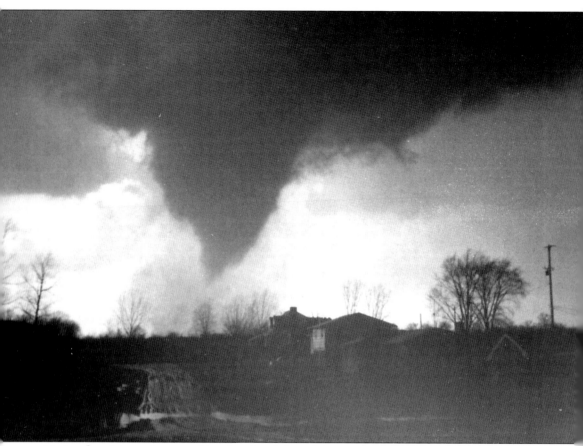

Marian Jane Meyer Annis and her family celebrated her mother's birthday in the basement of the Willow Drive home on April 3, 1956. They had heard a storm was coming, so they waited it out in the basement. They looked out the window to see boards flying into their home from across the river, as well as this funnel cloud. The tornado lifted the home above them and then it settled back down, doing little damage to the dwelling. The tornado killed 13 in Hudsonville, 4 in Standale, and 1 Thompsonville woman, according to early newspaper reports. Scores were injured. (Marian Annis.)

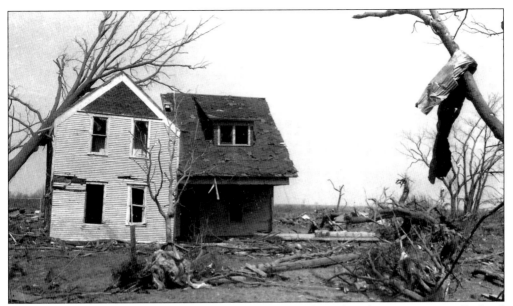

The destruction caused by the 1965 tornado that ripped through Belmont was severe. Richard Annis Sr. came home from work on the day of the tornado, telling the kids they could not leave because of the storm warning. He looked out the window and saw the funnel approaching, fearing it would take the house, but it turned up the railroad tracks, taking out houses on Samrick Avenue and Buth Drive instead. (Marian Annis.)

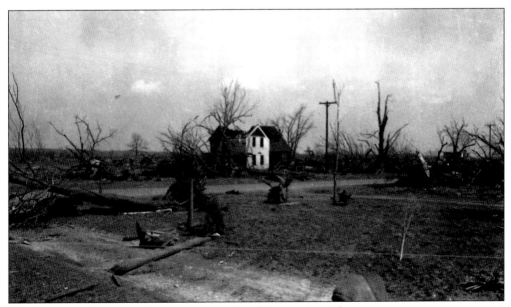

The damage to homes and trees was extensive. (Marian Annis.)

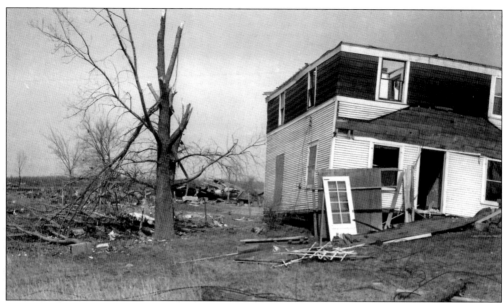

The tornado of 1965 drastically damaged homes and outbuildings, including buildings that were disintegrated around the cars and machinery they held. The tornado struck in the early evening of Palm Sunday, April 11. The tornado damaged neighboring townships as well, including nearby Alpine Township. (Marian Annis.)

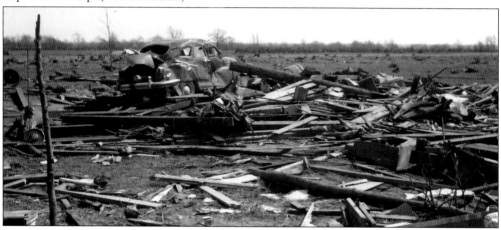

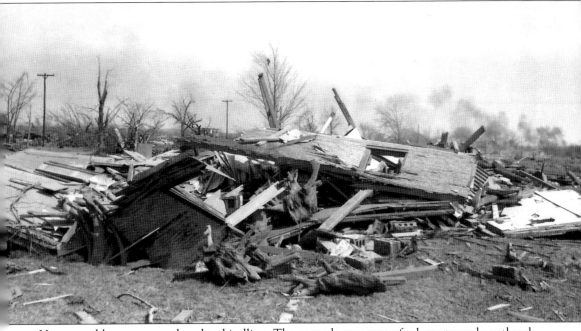

Homes and barns were reduced to kindling. The tornado was part of a large tornado outbreak involving 78 tornadoes that hit a 450-mile area from Iowa to Ohio, and a 200-mile swath from Kent County to Montgomery County, Indiana. (Marian Annis.)

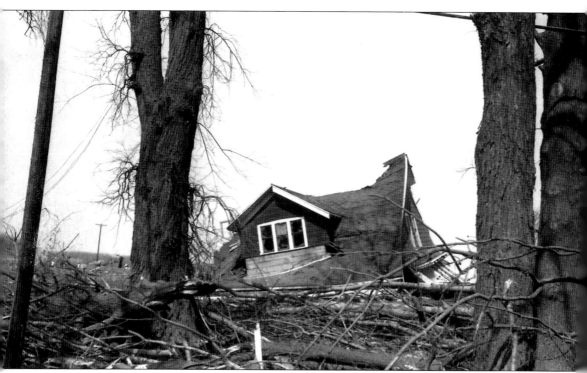

The damage to property was dramatic in Kent and Ottawa Counties, with five deaths and nearly 150 injured. Experts say 34 homes were destroyed and nearly 200 others damaged in the area. (Marian Annis.)

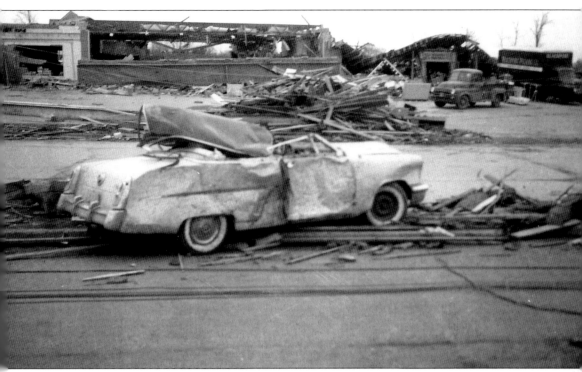

The city of Belmont was heavily damaged in the tornado. Total damage for the area was estimated at $15 million. The tornado was categorized an F4. As a result of this huge tornado outbreak, the National Weather Service implemented the "tornado watch" and "tornado warning" system. (Marian Annis.)

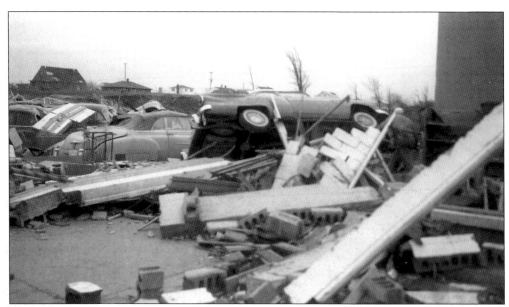

Buildings blew apart and cars were overturned in Belmont. (Marian Annis.)

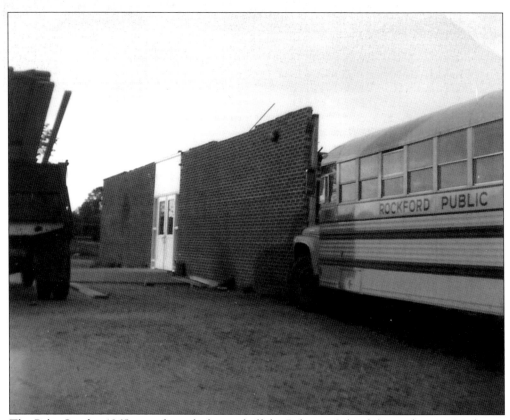

The Palm Sunday 1965 tornado took the roof off the Belmont School, located at 6097 Belmont Road. (Ruth Jost Kommer.)

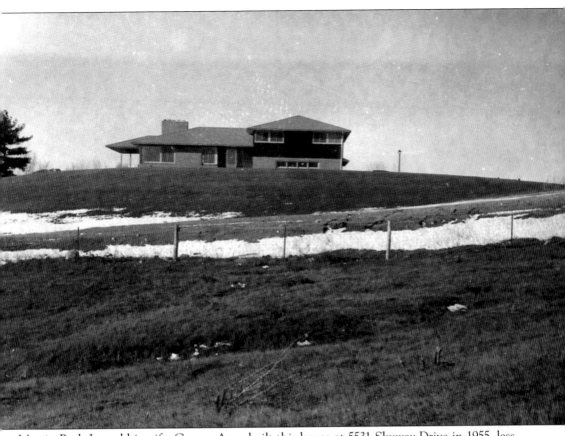

Martin Buth Jr. and his wife, George Ann, built this house at 5531 Skyway Drive in 1955, less than a mile from the Buth farm. In 1956, George Ann and her sons Martin III and George were sitting at the dinner table when George Ann looked out the window and said, "That looks like a tornado." She and the boys headed for the basement. When it finally became quiet, they walked up the stairs and could see the sky. The house had been destroyed, with the brick piled above them. Martin Buth was in Grand Rapids when the tornado, which wreaked havoc in Hudsonville and Standale, struck Plainfield Township. He headed home but was blocked from driving out to his house and was told that no one could have survived the storm. He walked to the rubble of his house, finding no family. He later found them safe at 1124 Buth Drive, their former home, where they had walked after the storm. The home on Skyway Drive was rebuilt. The Buths lived temporarily in a small home on the Buth farm. (Buth family.)

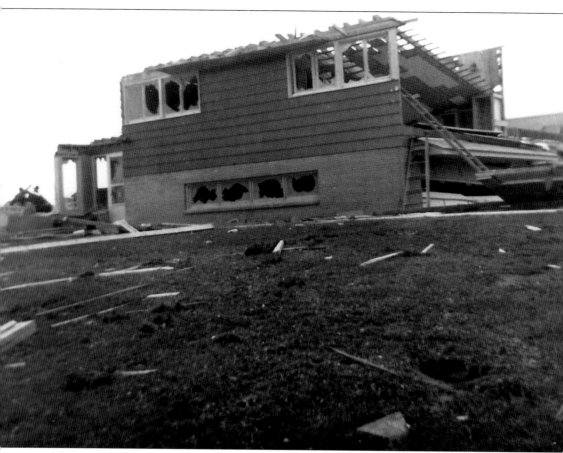

Martin and George Ann Buth completely rebuilt their home on Skyway Drive, this time incorporating changes that George Ann wanted after building the first home. The home still stands, now surrounded by many other homes that were built on the farmland. (Buth family.)

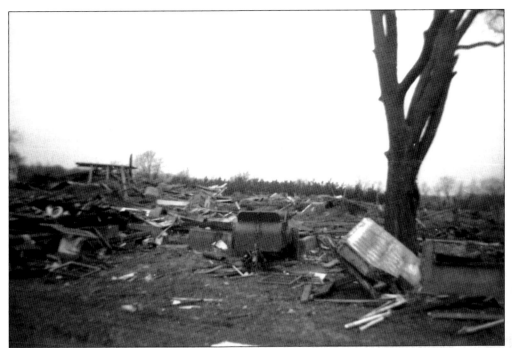

The Palm Sunday 1965 tornado completely destroyed barns and homes. (Chuck Weldon.)

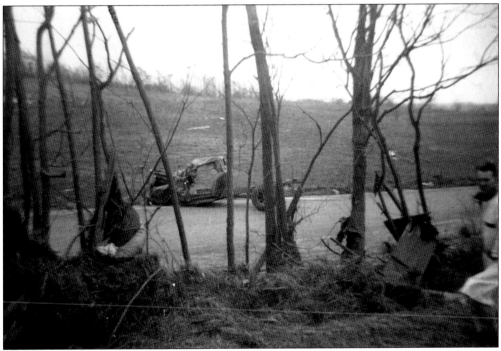

One farmer looks for what is left of his buildings, finding pieces scattered throughout the area. (Chuck Weldon.)

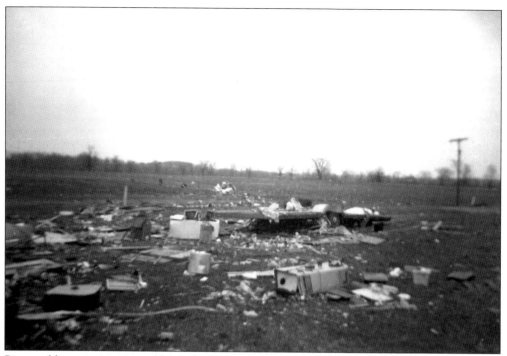

Pieces of farm equipment and home appliances lay scattered about. (Chuck Weldon.)

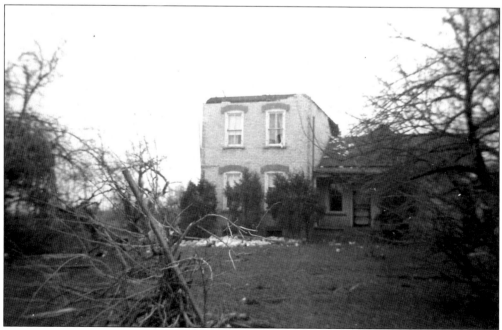

The roof was completely torn off this home in Plainfield Township. (Chuck Weldon.)

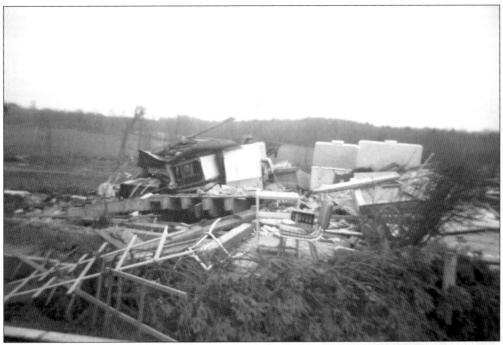

The 1965 tornado destroyed the home and barn of Max Samrick on Samrick Avenue. Cows died in the stanchions as the barn was destroyed (below). The deep freezers in the house, above, still stand on the right, used by the Samricks to store meat they sold. (Chuck Weldon.)

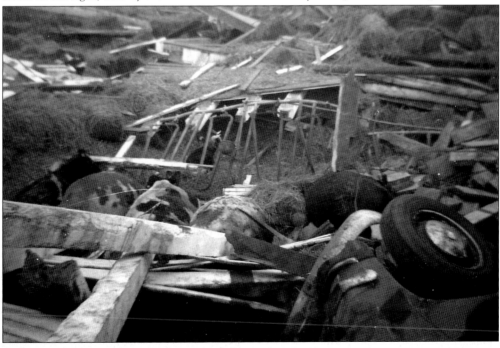

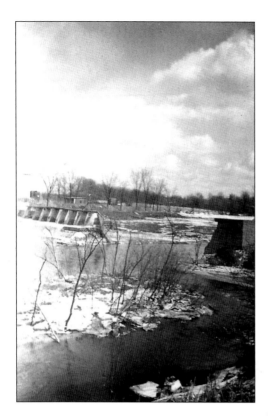

The Rogue River flooded in the spring of 1943, taking out the dam at Childsdale near the Childsdale Paper Mill (left). The dam was rebuilt, but the Department of Natural Resources had the dam taken out about 10 years ago. John Weldon is shown below standing on the edge of the Rogue River. (Chuck Weldon.)

Dexter Hamilton came to Plainfield Township in the late 1930s, and it was not long before he started organizing a township fire department and the volunteers to help fight fires. The process was slow, but he eventually got his volunteer squad. Hamilton became fire chief in 1945, a post he held until he retired in 1961. The township purchased its first fire truck in 1953. Shown here with the new truck are township officials and volunteers, from left to right, (first row) Glenn Hunsburger (township supervisor), trustee J. V. Smith, trustee Fred Tanner, Chief Dexter Hamilton (seated in truck), trustee Charlie Fisher, trustee Lloyd Solomon, trustee Dan Buth, trustee Earl (Hap) Woodworth, Bob Bellamy, and George Latimer; (second row) Pete Prawdzik, Charlie Wilkins, Danny Dannenberg, Archie Devereaux, Stonie Stoneburner, Neil DeRuiter, and Elmer Barney (standing on back of truck); (third row) Rex Kurant, Bob Cordes, Ben Benham, Rudy Johnson, Clark Rinkeviecz, Vern Dodd, and Louie Kurant. (Plainfield Township Historical Society.)

FARM RES. OF **WILLIAM W. BAKER** SEC. 3 PLAINFIELD TP. KENT CO. MICH.

The only resident represented in the *Illustrated Historical Atlas of Kent County Mich. 1876* was William W. Baker's farm in Section 3. His farm was located on Nine Mile Road east of Belmont Road. (Plainfield Township Historical Society.)

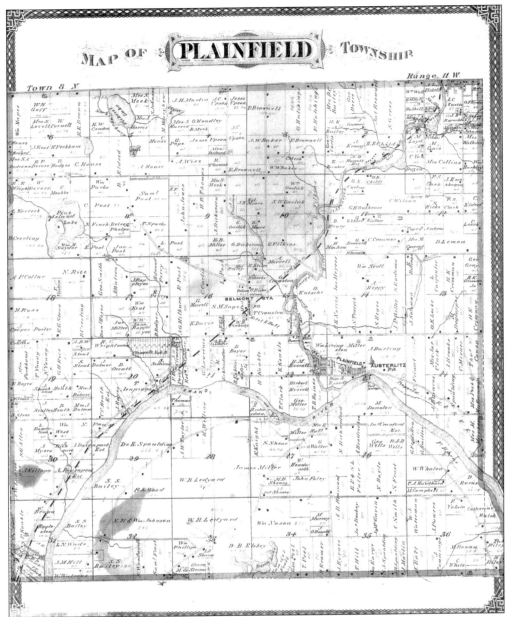

Plainfield Township was well established when the *Illustrated Historical Atlas of Kent County Mich. 1876* was published. Note the Grand River looping through the southern third of the township and the path of the railroad from southwest to northeast. (Plainfield Township Historical Society.)

ACROSS AMERICA, PEOPLE ARE DISCOVERING SOMETHING WONDERFUL. *THEIR HERITAGE.*

Arcadia Publishing is the leading local history publisher in the United States. With more than 3,000 titles in print and hundreds of new titles released every year, Arcadia has extensive specialized experience chronicling the history of communities and celebrating America's hidden stories, bringing to life the people, places, and events from the past. To discover the history of other communities across the nation, please visit:

www.arcadiapublishing.com

Customized search tools allow you to find regional history books about the town where you grew up, the cities where your friends and family live, the town where your parents met, or even that retirement spot you've been dreaming about.